HUDDERSFIELD
THROUGH TIME
Paul Chrystal

AMBERLEY

Thanks to Kirklees Image Archive for permission to use a number of pictures from their archive. Thanks too to Kirklees Stadium Development Ltd for permission to use the modern images of the John Smith Stadium. All modern photography ©Paul Chrystal unless credited otherwise.

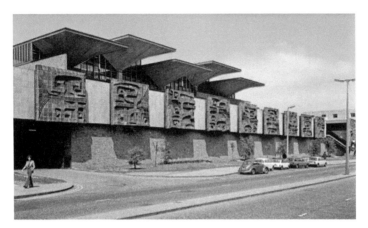

Market murals: In 1969 Huddersfield Corporation commissioned what is the world's largest ceramic sculpture. It is on the exterior of Queensgate Market, is Grade II listed and portrays the manufacture and cultivation of the produce sold in the market. It has been variously described as 'sculptural', 'lowing', 'poetic', 'stunning', 'modernist interpretation of Gothic', 'cathedral-like', 'dull concrete', 'dismal', and as 'greying concrete'.

Front cover illustration: Huddersfield Railway Station with taxis to hire in 2016 and around 1906

Back cover illustration: Huddersfield suffragettes protesting in style; celebrating Yorkshire Day in comfort

First published 2016

Amberley Publishing
The Hill, Stroud, Gloucestershire, GL5 4EP
www.amberley-books.com

Copyright © Paul Chrystal, 2016

The right of Paul Chrystal to be identified as the
Author of this work has been asserted in accordance with
the Copyrights, Designs and Patents Act 1988.

ISBN 978 1 4456 5851 3 (print)
ISBN 978 1 4456 5852 0 (ebook)

British Library Cataloguing in Publication Data.
A catalogue record for this book is available from the British Library.

Typesetting by Amberley Publishing.
Printed in Great Britain.

Introduction

Huddersfield Through Time give a unique glimpse of how the town of Huddersfield was at the close of the nineteenth century and in the early years of the twentieth century. It compares the way things were then, using old photographs juxtaposed with direct modern equivalents taken in the spring of 2016. From these, the reader can see very clearly just how much things have changed over the years: streets, buildings, shops, industry, transport, entertainment and Huddersfield people themselves. In illuminating these changes, the reader also comes away from the book with a social history of the town and of its immediate vicinity, thanks to incisive and researched captions. Outlying districts such as Berry Brow and nearby villages like Denby Dale (home of the world's biggest meat pie), Kirkburton and Skelmanthorpe, and the M62 motorway, so vital to Huddersfield's economy, are also covered.

This is how the town was described around 1820:

HUDDERSFIELD, a parish-town, in Agbrigg-division of Agbrigg and Morley, liberty of Pontefract; 5 miles from Halifax and Dewsbury, 12¾ from Penistone, 13 from Wakefield, 14 from Bradford, 16 from Leeds, 18 from Barnsley, 24 from Manchester, (Lanc.) 39 from York, 189 from London. Market, Tuesday, for woollen cloth, provisions, &c. Fairs, May 14 and 15, and October 4, for pedlary ware, &c. Bankers: Old Bank, Messrs. Dobson and Sons, draw on Messrs. Masterman, Peters, and Co. 2, White Hart Court, Gracechurch Street...Principal Inns, Rose and Crown, George Inn, Swan with two Necks, Pack Horse, and Ramsden Arms. Pop. 13,284. The Church is a Vicarage, dedicated to St. Peter, in the deanery of Pontefract, value, £7. 13s. 4d. Patron, Sir John Ramsden, Bart.

Edited from various nineteenth-century sources by Colin Hinson © 2013

The town of Huddersfield can boast many impressive achievements, some of them, perhaps, surprising, particularly to those who are not so familiar with the area. It is the eleventh largest town in the United Kingdom with a population of 162,949 at the 2011 census. It played an active role in the Industrial Revolution and is the birthplace of the rugby league, British Labour Prime Minister Harold Wilson and film star James Mason. Herbert Asquith, Liberal Prime Minister from 1908 to 1916, moved to No. 52 West Parade in Huddersfield from Morley when he was seven years old.

Indeed, over the decades, Huddersfield has been a veritable hotbed of political, social and industrial reform, including the campaign for the reform of Parliament, Chartism, the creation of the Independent Labour Party, Women's Suffrage, Socialist Sunday schools, the Co-operative movement and much more. The White Hart was a meeting place for Huddersfield's Luddites, the committee of the Radical candidate Captain Wood was based here in the election of 1832; Robert Owen's Utopia – the Hall of Science in Bath Street was built in 1839 by disciples of Owen; in the 1840s local Chartists also used the building – it later became a Baptist chapel. Factory reform in the 1830s led by Richard Oastler, 'The Factory King', and leader of the campaign against child labour, returned to Huddersfield after his release from prison. Thornton's Temperance Hotel 1855–1909 in Huddersfield was established by the secularist Joseph Thornton, and became a centre of radical discussion. Several leading secularists stayed at the hotel, including Charles Bradlaugh; meetings of a local branch of the Fabian Society were held at Thornton's Temperance Hotel in the 1880s which led to the formation of the local

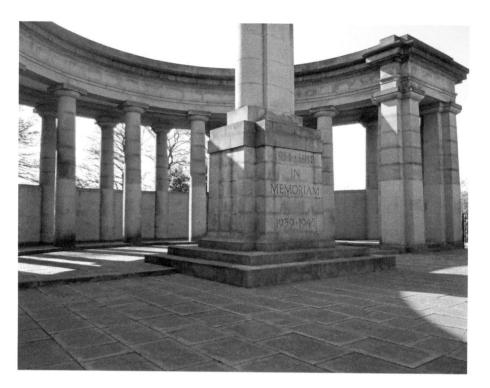

Huddersfield's magnificent war memorial in Greenhead Park.

Independent Labour Party. Former clubrooms in St Peter's Street were the headquarters for the Huddersfield branch of the ILP, formed in 1892, the forerunner of the Labour Party. From 1906 to 1936 the Socialist Sunday school met in an upstairs room here. With the Friendly and Trades Club it was a centre for the town's anti-war movement during the First World War.

More recently, the town has been voted the third happiest place to live in England. It is a treasure trove of handsome architecture with more than 3,019 listed buildings in the area, the most in Yorkshire, over 200 of which are in the town centre. Huddersfield Town FC became the first club to win the League Championship three times in a row; only three other teams have done that. The University of Huddersfield was voted *The Times Higher Education* University of the Year in 2013; Sir Patrick Stewart OBE, of *Star Trek* fame, was chancellor there until July 2015 when he was succeeded by Prince Andrew, Duke of York. On Christmas Day 1977, the Sex Pistols played their last two British shows: one a matinee for the children of striking fire fighters, at Ivanhoe's nightclub.

In terms of ethnicity, approximately 81.0 per cent of Huddersfield people are white, 12.4 per cent Asian or British Asian, compared to 1.4 per cent for England as a whole and 3.6 per cent Black or Black British. For religion, of those that state or profess a religion, 77,843 are Christians (64.0 per cent; 71.7 per cent in England generally); Buddhist are 133 (0.1 per cent, 0.3 per cent); Hindu: 577 (0.5, 1.1); Jewish: 70 (0.1, 0.5) and Muslim: 12,147 (10.0, 3.0).

Harrogate Through Time encapsulates much of the history of the town in the following ninety pages or so of comparative photographs and informative text, providing the reader with a short but highly informative survey of this elegant and historical northern town.

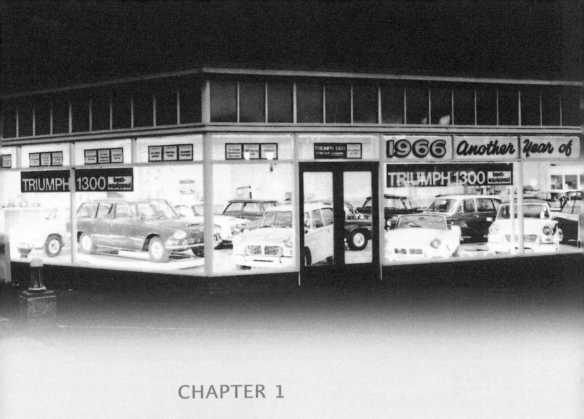

CHAPTER 1

Trade

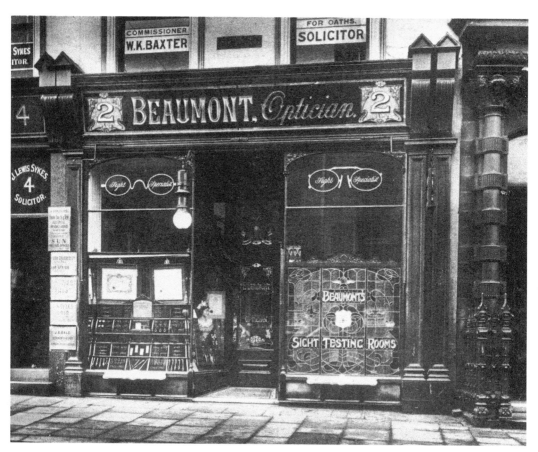

Beaumont's

The 'sight specialists' in New Street. Beaumont's was established in 1901 and still trades as an independent family run business, although the family is not now the Beaumont's. The firm is today based in Kingsgate Shopping Centre, where they moved to in 2011. The image on page 5 shows the Triumph dealership which was on Queensgate. The original Boyes garage was at Chapel Hill on the Inner Ring Road at Witon's Corner; it was demolished in the 1960s. The new image shows a car splendidly decked out with everything, including the proverbial kitchen sink, to celebrate Yorkshire Day.

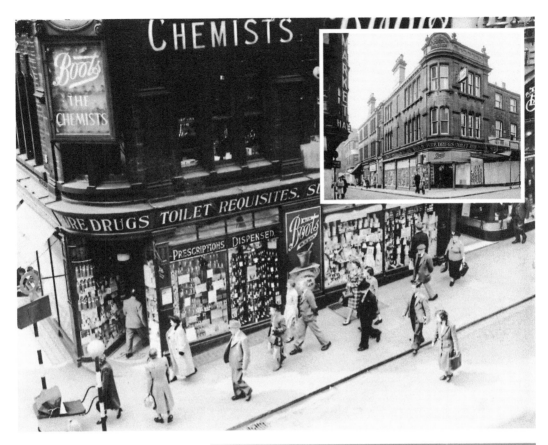

Devonshire Buildings

On the corner of King Street and Victoria Lane in 1950. A branch of Boots the Chemist clearly occupies the site. Huddersfield's history starts in earnest at Slack, a Roman fort or *castellum*, near Outlane, west of Huddersfield. It was first discovered by The Huddersfield Archaeological and Topographical Society in 1865; the fort was made of turf and wood to defend the Roman road in the governorship of Agricola in around AD 79. Outside the fort walls was a stone bathhouse and a *vicus*: a small settlement of wooden huts.

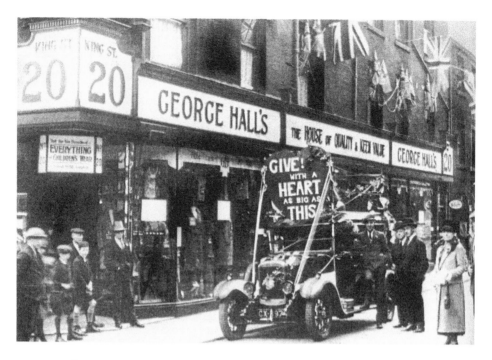

George Hall's

The town's top tailors, located at No. 20 King Street. They later moved to premises in the Ritz building on Market Street where WH Smith is now. Apart from men's and ladies tailoring they had a good line in 'general mourning': 'ready to wear MOURNING always ready', afternoon frocks, net curtains and household cottons. The modern image shows fashionable shops in the Byram Arcade.

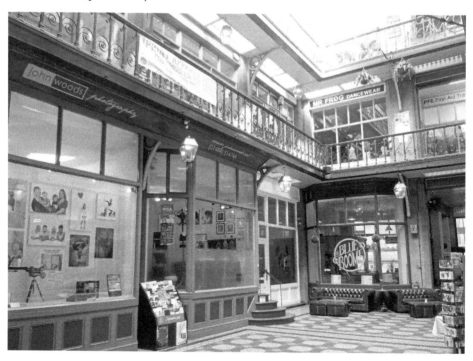

King's Head Buildings, Cloth Hall Street
An 1820 description of the town:

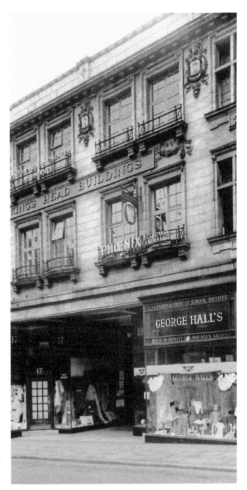

Huddersfield, derived from Hoder or Hudder, the first Saxon planter of the place, stands on the river Colne, which rising near the source of the Don, above Holme Frith, falls into the Calder, near Nunbrook. Of the valley immediately, formed by this stream, and of the small collateral gullies which fall into its course, with a very small quantity of level ground upon its banks, the parish of Huddersfield is formed. For the antiquary we are not aware that Huddersfield has any one thing of interest to offer. At the time Domesday Book was compiled, it had, either in consequence of the Danish ravages, or those of the conqueror [the harrying of the north by William I], relapsed into a mere waste. It is now one of the most populous hives in all the manufacturing district. This parish was originally separated from that of Dewsbury, and the parish church erected and endowed under the influence of one of the earlier Lacies; and, that, by one of them it was given, and afterwards appropriated to the Priory of Nostel.

Edited from various nineteenth-century sources
by Colin Hinson © 2013

http://www.genuki.org.uk/big/eng/YKS/WRY/
Huddersfield/index.html

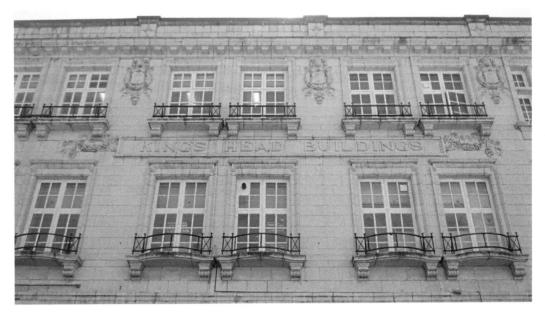

New Street

A busy New Street in 1952 with a branch of Fifty Shilling Tailors on the right. In new money, 50 shillings is approximately equal to £2.50. Fifty Shilling Tailors was founded in Leeds in 1905 by Henry Price; at its height it had over 400 stores in the UK. In 1958 the company was sold to UDS, United Drapery Stores, and rebranded as John Collier. In 1985 it was sold to the Burton Group; the brand no longer exists. The new picture shows New Street in 2016.

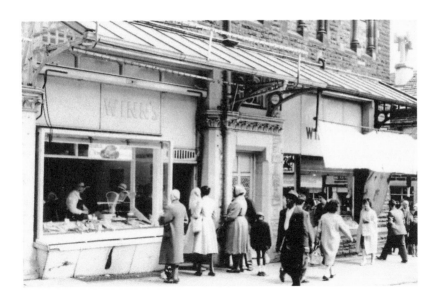

Winn's

The town's top fish, game and poultry shop opened in 1961. Winn's moved into the Queensgate Market after the demolition of the old market hall and was well known for selling exotic species of marine life such as shark, octopus and squid as well as plaice and haddock. Their motto was 'If it swims, we've got it'. In 1987, the owners opened The Good Food Business in Macaulay Street; this gave an opportunity to expand from fish to include a butchers' counter, a delicatessen and a café. Yvonne Beecroft's fish stall in Queensgate Market is pictured in the new photograph.

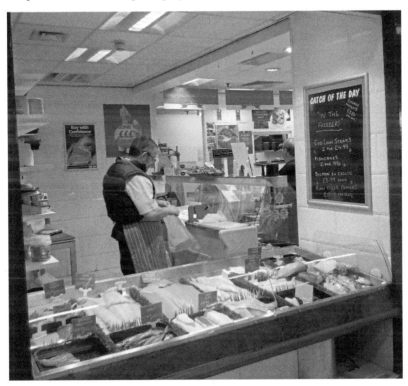

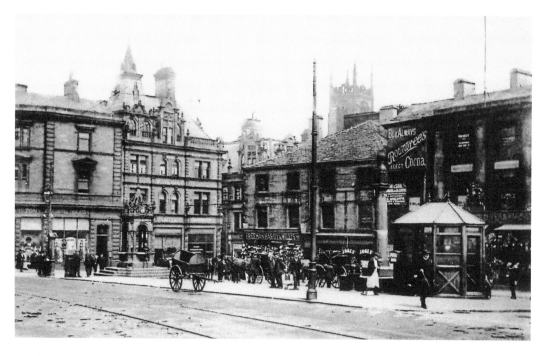

Market Place

Two views of Market Place in the early 1900s. The Waverley Hotel is on the left with Burton's the Tailors. Market Place has always been the epicentre of the town and the scene of much social protest. In 1799 a food riot took place here: the square and the George Inn were barricaded for fear of riots in 1820. In 1842 the Riot Act was read and cavalry used to disperse strikers who had invaded the town from the Holme and Colne Valleys. The original George Inn was dismantled to open up John William Street, and rebuilt in St Peter's Street.

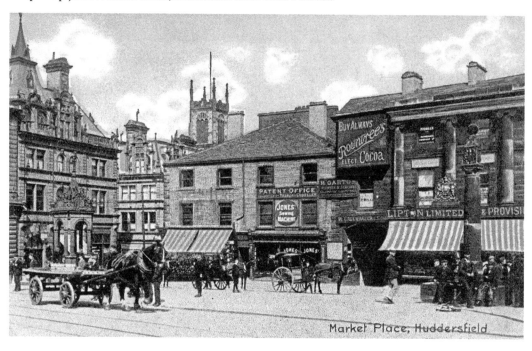

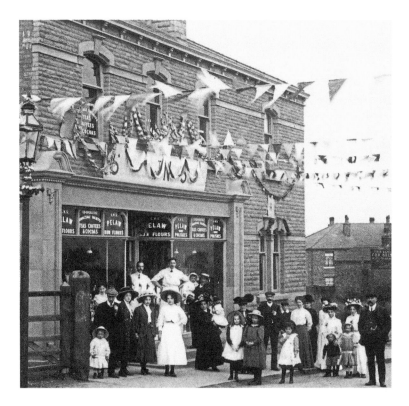

The Co-op

Customers and staff outside a new branch of the Co-op which opened here in November 1934. The sign, obscured by bunting, says 'success to our new stores'. The Huddersfield Industrial Society was founded in 1860, with a grocer's in part of an old building in Buxton Road, now New Street. The society then acquired several shops in outlying districts before developing the town centre store, in what was known as Johnson's Buildings in 1886–87, which became the Central Departmental Co-Operative Store. The Market Place in 2016 is pictured in the new shot – it contrasts starkly with the imposing and grand buildings on page 12 – with its drab new buildings and any-town anonymous chains.

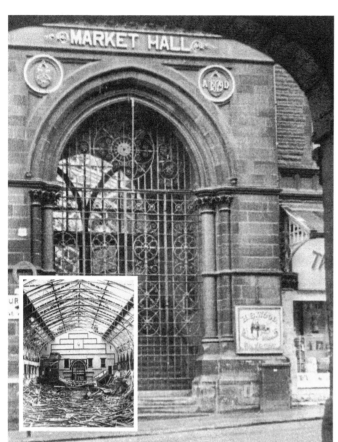

Market Hall

Market Hall was opened in 1880 and demolished in 1970, as shown in the inset. The grand gated entrance on King Street allowed access to the upper storey. The glazed roof can just be made out through the gates in the upper picture – the gates were salvaged from the demolition and are now at Shaw's retail park at Aspley. The lower picture shows the interior of the Market Hall in the 1960s. Lodges' stall is visible: they opened the town's first supermarket but called it a day as market traders when it was demolished rather than move to the new market. John Lewis and Marks and Spencer had a market stall in Huddersfield.

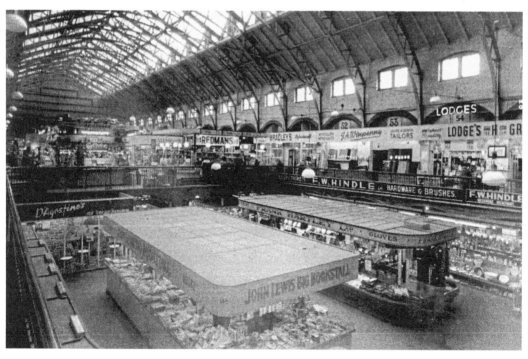

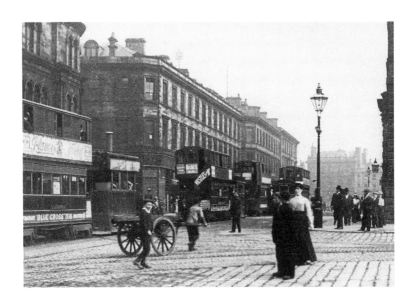

John William Street

Steam trams line the street in the above image from 1903. The fine buildings remain in 2016. It is named after John William Ramsden (14 Sep 1831–15 April 1914) the Liberal Party politician and landowner; Sir John Ramsden was the major force behind early Huddersfield:

> Sir John Ramsden, Bart. is now owner of the whole of Huddersfield, with the exception of two or three houses... in 1765, [he] built an excellent cloth hall for the accommodation of the manufacturers. It is divided into streets, the stalls and benches of which are generally filled with cloths. The doors are open early every Tuesday morning, the market day, and closed at half past twelve o'clock at noon and are again opened at three in the afternoon, for the removal of cloth, &c.

Edited from various nineteenth-century sources by Colin Hinson © 2013

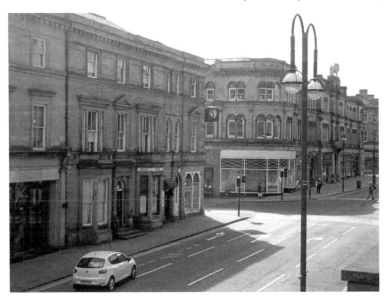

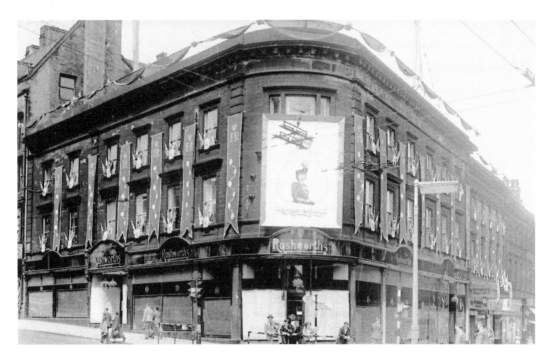

Rushworth's

On the corner of Westgate and John William Street at Nos 1–9, known as Rushworth's Corner, in 1953. In October 1960 a double-faced electric clock, the first of its kind in the UK, was installed above Rushworth's; it has a 3-foot dial and continuous revolution. Currently, the premises are occupied by Nando's. The older photo shows the store decked out to celebrate the coronation of Queen Elizabeth II in 1953: 'Long live the Queen'. The new photo is of the magnificent Lion Arcade opposite the station.

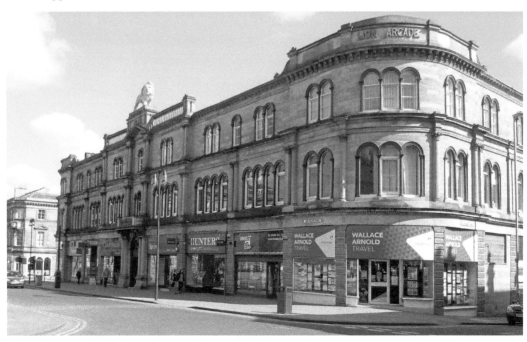

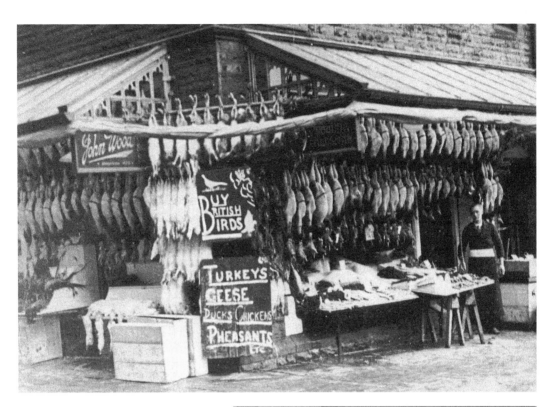

John Wood's Poultry, Game and Fish

Victoria Street in the 1930s, but now in Queensgate Market Arcade. Wood's hired the services of a night watchman to guard the poultry as it could not be taken down every evening. John Wood is on the left. The business was opened in 1898 in Market Walk by Henry Wood, moving in 1900 to Victoria Street. The family continues to run the business in the new Market Hall. The new photo is of R. C. Russell in the Queensgate Market.

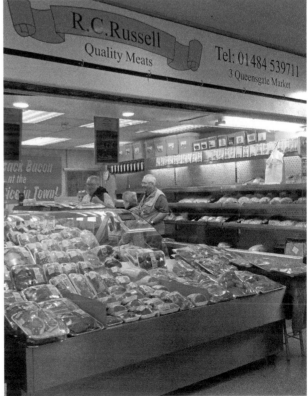

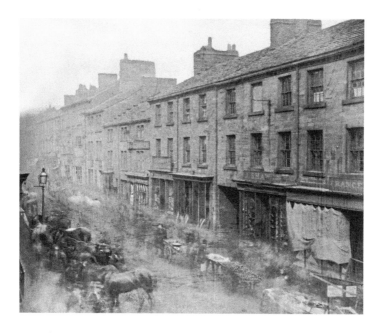

Market Day on Crofts Church Street

The Ramsden story continues, making as he did, Huddersfield the town it is today:

> Sir John Ramsden also added to the facility of Inland navigation, by cutting a Canal to Huddersfield, which bears his name: it branches from the Calder navigation at Cooper Bridge, is brought up to the King's Mills, at Huddersfield, where it joins the Huddersfield Canal on the South end of the town, thereby affording a direct communication both east and westward, and ultimately to any part of the kingdom, which is of the greatest importance to the town. The trade of Huddersfield comprises a large share of the clothing trade in this county, particularly of the finer articles. These consist of broad and narrow cloths, fancy cloths as elastics, beveretts, serges, karseymeres, and various other woollen articles.

<div align="right">Edited from various nineteenth-century sources by Colin Hinson © 2013</div>

The modern image shows a bustling Open Market.

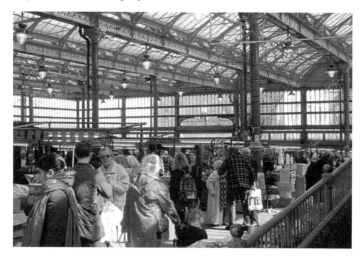

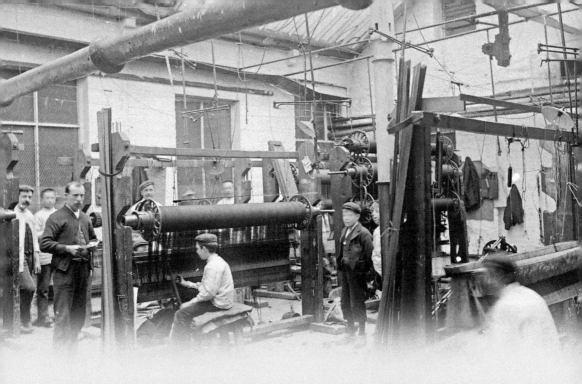

CHAPTER 2

Industry

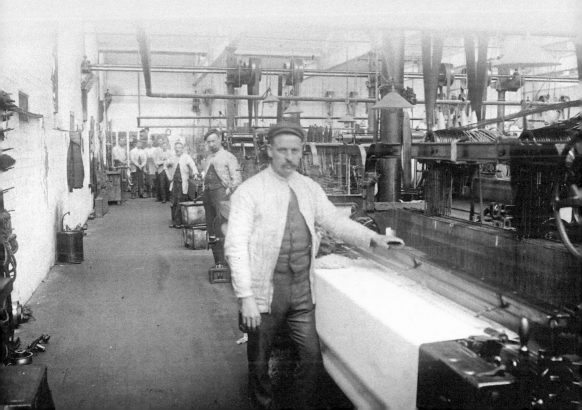

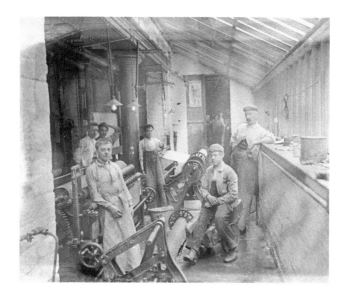

Sizers

Sizers at Kaye and Stewarts Mill, *c.* 1910. The boom period for Huddersfield's textile industry was the late nineteenth and early twentieth century when the town established for itself a global reputation for the manufacture of fine woollen and worsted cloth. Workers handed down their skills from generation to generation and families often worked in the same mill for three generations. There were more Rolls-Royce cars here than in any other town in England. Kaye and Stewart was founded in 1883. In 1911 there were 22,000 people working in textiles in Huddersfield – one third of all men and two thirds of all women. In 1961 there were a total of 182 registered mills in and around Huddersfield, the Colne and Holme Valleys, Skelmanthorpe and Denby Dale. Of these, ninety-five were in the central Huddersfield area. In the area currently covered by Kirklees, there were 284 textile mills. The image on page 19 shows the Scalding Room and a weaver at Kaye and Stewarts Mill in 1910 – note the young boys. Huddersfield pubs were named after aspects of the industry: here is the Croppers Arms in Westbourne Road.

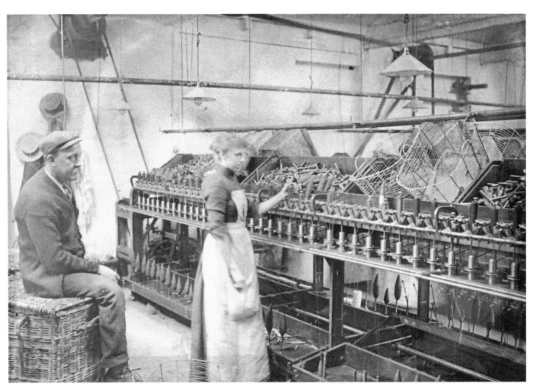

Winding Bobbins

Bobbin winders, Kaye and Stewarts Mill, 1910. The English language has been enriched by borrowings from the textile industry.

'Dyed in the wool' comes from when raw wool is dyed before it is spun into yarn; it colours the fibres the whole way through, rather than being 'surface dyed'. So, if you are a 'dyed in the wool' Yorkshire woman, you are a Yorkshire through and through.

'Run of the mill' is used to describe something quite ordinary. It derives from cloth coming out of the mill before going through quality control, so it may well have imperfections.

'Being on tenterhooks' means to be anxious. It originally referred to the tension applied to newly woven cloth to stretch it evenly and dry it without shrinkage. Other textile-derived words and phrases include: pulling the wool over someone's eyes, in the loop, warped (as in 'sense of humour'), cut from the same cloth, the full nine yards, flannel and shoddy.

The Slubbers Arms is at No. 1 Halifax Old Road; it gets its name from to draw out and twist a sliver of fibre before spinning.

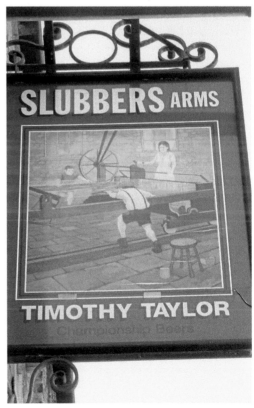

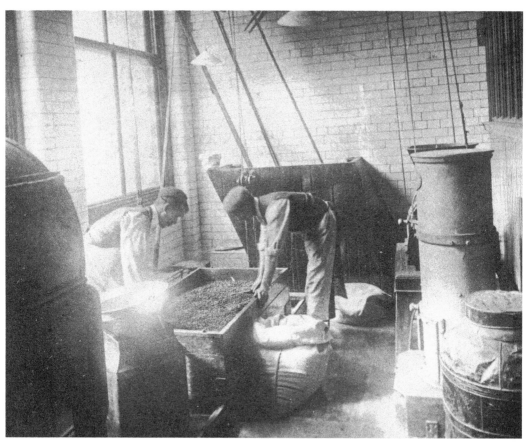

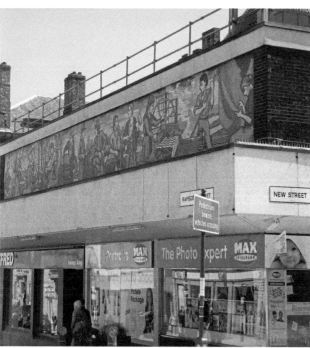

Wallace's, St John's Road
'Wallace's Limited 1897' is inscribed over the door of this fine building in St John's Road. This was probably the offices and warehouse of Wallace's the grocers, who had several shops in the Huddersfield area. The two workers, one of which is William Cousins on the left, are grinding coffee. The 65-feet-long, 8-feet-high mosaic mural above Ramsden Street shows various aspects of Huddersfield's textile industry by Harold Blackburn in 1966; its official title is *The Development of the Woollen Industry From a Cottage Craft Practised as an Ancillary to Farming, Up to the Beginning of the Industrial Revolution.*

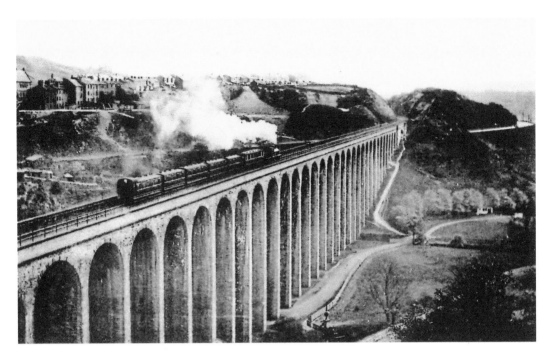

Lockwood Viaduct I

Pictured here in the early 1900s, the majestic viaduct is Grade II listed with its thirty-two arches; it spans the valley of the River Holme and connects the line to Berry Brow. Before the mid-1970s Lockwood had its own large goods yard, coal yard, sidings and station master's house; it is on the Penistone Line between Huddersfield and Sheffield.

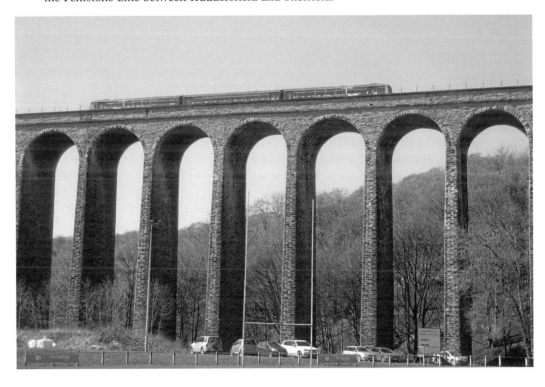

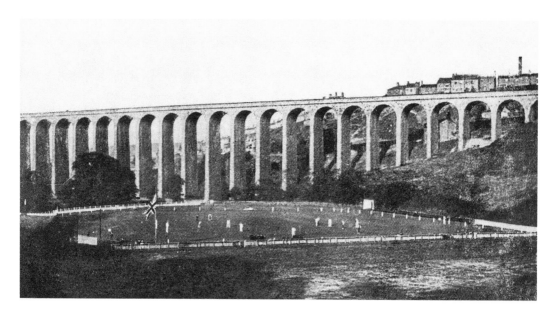

Lockwood Viaduct II...

...and cricketers in a quintessential northern English scene. The goods yards were predominantly used to service and supply raw materials to the former engineering works of David Brown Ltd. This, the Park Works division of David Brown's, produced gearboxes for industrial machinery, hydraulic drives and military armoured vehicles. The gear box that turns the top of the Post Office Tower in London was designed and built here. Rugby Union is the sport played here now, courtesy of...

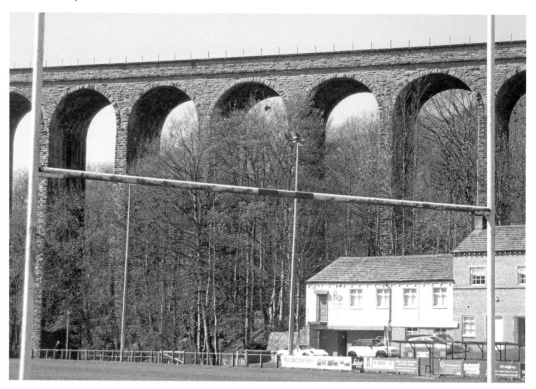

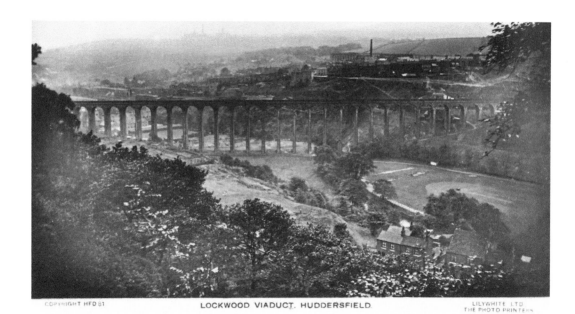

LOCKWOOD VIADUCT. HUDDERSFIELD.

Lockwood Viaduct III...

...Huddersfield Rugby Union Football Club. The club is at Lockwood Park, below and on both sides of the railway viaduct, in the former Bentley & Shaws Brewery. Timothy Bentley, founder of Bentley & Shaws, is the inventor of the Stone Square system of brewing beer. This permitted high levels of carbon dioxide to remain in the beer during fermentation, giving it a unique flavour and smoothness when served. The stone used in the brewery came from stone quarries in nearby Elland. The brewery was taken over by Bass Charrington who closed it down in the late 1960s.

25

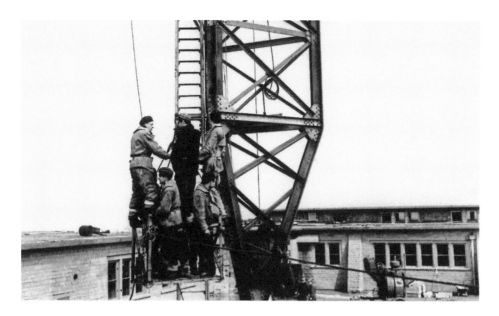

Holme Moss TV Mast

Shown here under construction in May 1951, Holme Moss transmitting station was the BBC's third public television transmitter, launched on 12 October 1951. VHF Radio broadcasts began in December 1956, for the Home, Light, and Third Programme as they were then called; even to this day, the equivalents of these three stations (BBC Radios 2–4) operate on the same frequencies as they did in 1956. BBC Local Radio services were added in the early 1970s and then independent, commercial Classic FM in 1992. Transmissions cover Greater Manchester and Cheshire and most of Yorkshire, although signals can be received in London and Scotland, in Ireland and mainland Europe. The base of the station is 524 m above sea level with the mast adding another 228 m on top of that. The mast weighs 140 tons. The lower picture shows damage to the mast at Emley Moor.

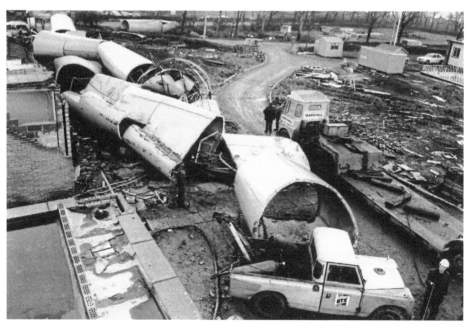

Elmley Moor

Emley Moor Transmitting Station is a telecommunications and broadcasting facility on Emley Moor, 1.6 km west of Emley. A Grade II-listed 330.4 m concrete tower, it is currently the tallest freestanding structure in the United Kingdom, the seventh tallest freestanding structure in the European Union, fourth tallest tower in the European Union, and twenty-fourth tallest tower in the world. This is the third antenna support structure to occupy the site: the original 135-metre lattice tower was erected in 1956 to provide Independent Television broadcasts to the Yorkshire area transmitting Granada TV programmes on weekdays and ABC TV programmes at weekends. It was replaced by a taller 385.5-metre guyed mast in 1964. The damage to Elmley Mast in March 1969 was caused by a combination of strong winds and heavy ice that had formed around the top of the mast and on the guy wires which brought the structure down. Reaching the tower room at 274 m involves a seven minute journey by lift; the mast's foundations penetrate 6 m into the ground and the whole structure weighs 11,200 tonnes. The lower picture shows the mast from Kirkburton.

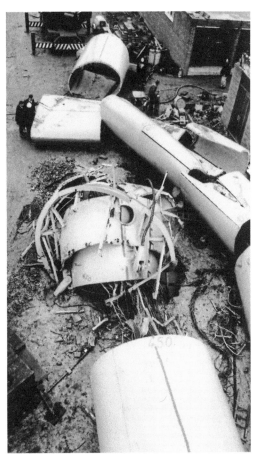

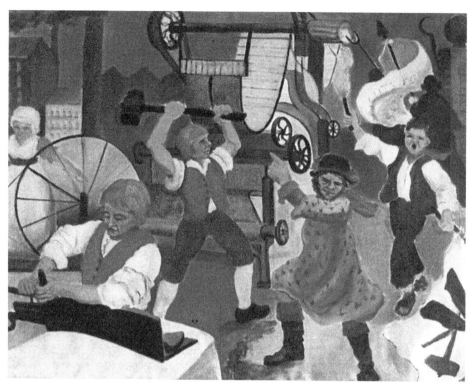

Man v Machine?
The Luddites of West Yorkshire

Friends and Fellow Mortals... will you still calmly submit to endure that arrogance, Tyranny and oppression that hath so long been exercised over you – Will your suffer your Children to be tortured out of existence by beings the Lustres of hunger and nakedness and yourselves insolently degraded by those very men that are living in luxury and Extravagance from the fruits of your labour"

West Yorkshire Archive Service

Luddites in Huddersfield

The Luddites may well have been proud of the damage done to Emley Mast. The upper image is of a 6 feet by 4 feet canvas depicting scenes from the Luddite uprising in the West Riding by local artist Cath Everett. The lower image shows a leaflet promoting an exhibition of Luddite activity in West Yorkshire. The Luddites' campaign of violence began in 1812; they were incensed by the introduction of new machinery, especially the shear frame, which was making skilled workers, the croppers, redundant. Their concerns matched those of large sections of the poor in general who were restless about the prolonged wars with France and an economic crisis that was putting people out of work and raising food prices. By the summer of 1812, Huddersfield was an armed camp. By 26 June almost 400 soldiers were stationed there billeted in public houses; it is suggested that there were more British troops in Yorkshire than Wellington had in Spain. The White Horse was a haunt of the Luddites when in 1812 the violence began in West Yorkshire textile districts around Huddersfield; this included the usual machine smashing and attacks on property; on 28 April 1812, however, the murder of William Horsfall, a local wool textile manufacturer and a leading advocate of the new machinery, added a more sinister element to the Luddite activism.

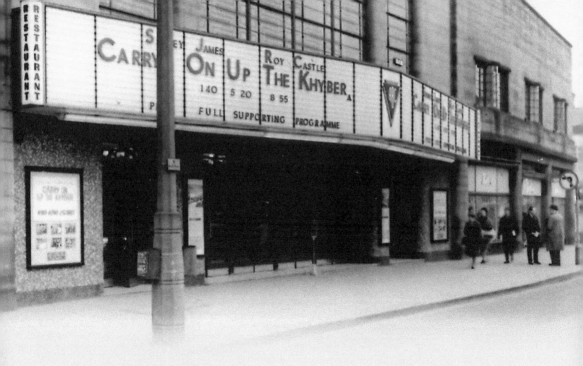

CHAPTER 3

Cinemas & Theatres

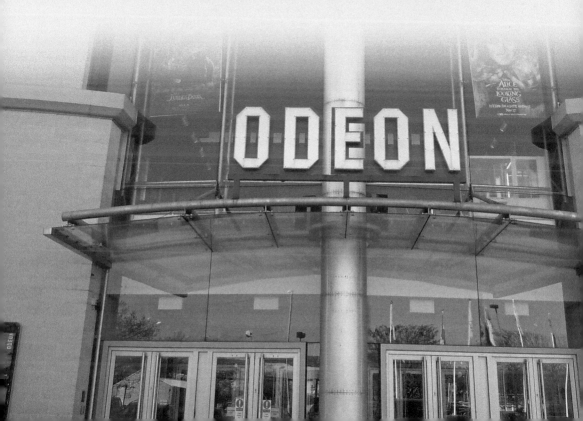

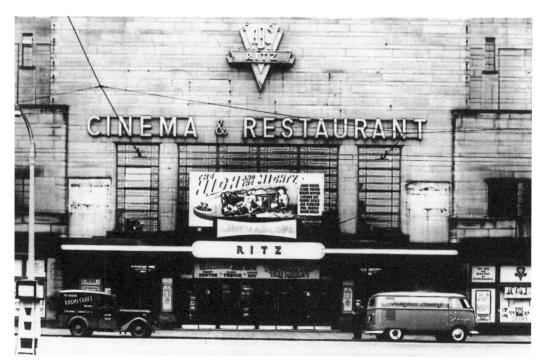

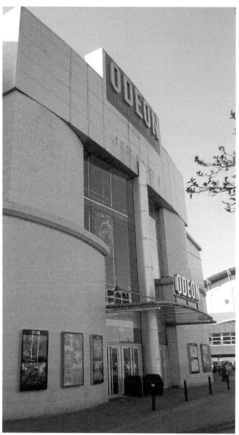

The ABC-Ritz and the Beatles

John Wayne in *The High and the Mighty* was on the bill in this photo. The Beatles performed here, taking the stage at 6.15 p.m. on 29 November 1963 in front of 2,000 fans. It was the same day that 'I Want To Hold Your Hand/This Boy' was released. The group performed ten songs at the night's two concerts: 'I Saw Her Standing There', 'From Me To You', 'All My Loving', 'You Really Got A Hold On Me', 'Roll Over Beethoven', 'Boy', 'Till There Was You', 'She Loves You', 'Money (That's What I Want)' and 'Twist And Shout'. The image on page 29 shows Sid James and Roy Castle starring in *Carry on Up the Khyber* in March 1969. Built on the site of the 1770s Cloth Hall, the ABC-Ritz was on Market Street, cost £100,000 and opened in February 1936 with Jessie Mathews in *First A Girl* and Billy Cotton's Band on stage. It was originally a 2,036 seat single-screen cinema with stalls and circle and a café and ballroom. The Ritz was taken over by Associated British Cinemas (ABC) in October 1937, but not rebadged as an ABC until 1961. The ABC closed in March 1983 and was demolished to make way for a supermarket in the late '80s. The modern images on pages 29 and 30 show the cinema experience in 2016 – at the Odeon.

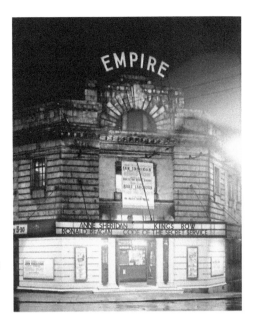

Huddersfield Empire

Built on the corner of John William Street and
Brook Street, the opening performance was
Kismet on 8 March 1915. In May 1940 it was
completely renovated to reopen that July as the
New Empire. Further renovation followed in
1951; in 1980 the Empire ceased to be used as a
cinema, as the modern image shows.

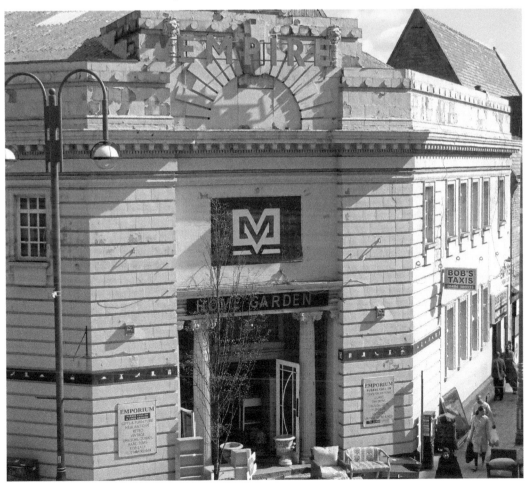

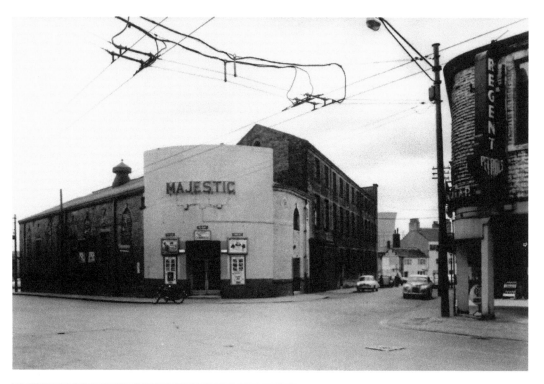

The Majestic

The Majestic originally opened as the Olympia Cinema in October 1912, on Viaduct Street just around the corner from the Empire Picture House. After a short closure, it reopened on Christmas Day 1916 as the Star Picture House; from February 1929 it was renamed the New Star Picture House, or the 'fleapit' or 'the rumble', because Huddersfield Station is only 20 feet away and trains were clearly audible. In August 1939 a fire destroyed the stage and screen. Renovated in art deco style, it reopened as the Majestic Cinema in January 1940, surviving until 1964 when it became a retail store known as Majestic Designs. The auditorium became a car repair workshop known as Majestic Motors and, stalls apart, remains totally intact as a car storage and hire firm. The new photograph shows the foyer of the Lawrence Batley Theatre in Queen Street.

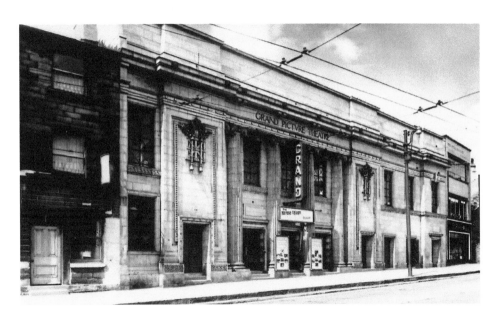

The Grand Cinema

Opened on Manchester Road in July 1953 when *The Maltese Falcon* was showing. The theatre was built on the site of foundations originally intended for the engine house of a tramway company. The £32,000 development opened in March 1921; its first performance was *J'Accuse*, (1919), a French silent film directed by Abel Gance which juxtaposes a romantic drama with the realistic portrayal of the horrors of the First World War. In April 1932 a fire caused extensive damage to the stalls but it soon reopened with *Frankenstein*. The Grand ended life as a cinema in June 1957 and became a nightclub, first known as Eros and later Ivanhoe's. This closed in 1993.

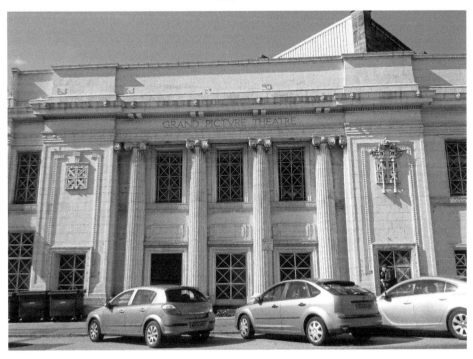

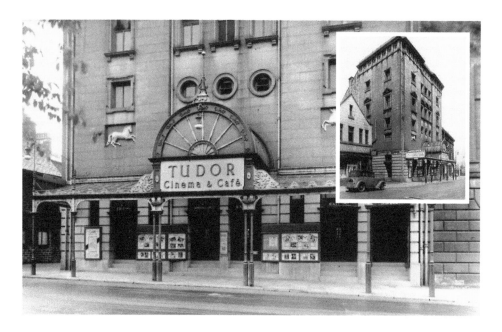

Tudor Cinema

This shows the Tudor in July 1953 with its wonderful façade. It started life as the Armoury, a former riding school on Ramsden Street which opened to the public in 1848 when Batty's Circus came to town. It was later used as a drill hall and arsenal, opening as the Theatre Royal in 1881. It became the Hippodrome Theatre in 1905, and was renamed the Hippodrome and Opera House in 1926. In 1958 it was rebadged from the Tudor House Super Cinema to the Essoldo; 1967 saw it badly damaged by fire and refurbished and renamed the Classic; it closed in 1998 when the building was split: the front became the Rat & Parrot, then Livingstones and Club Che; the Zetland Street side of the cinema becoming the Varsity.

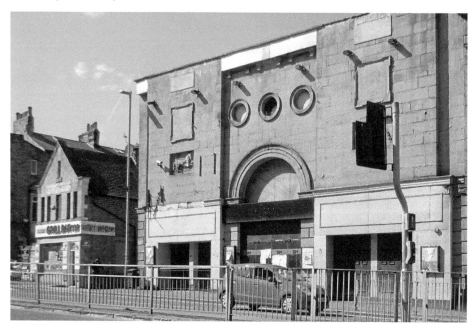

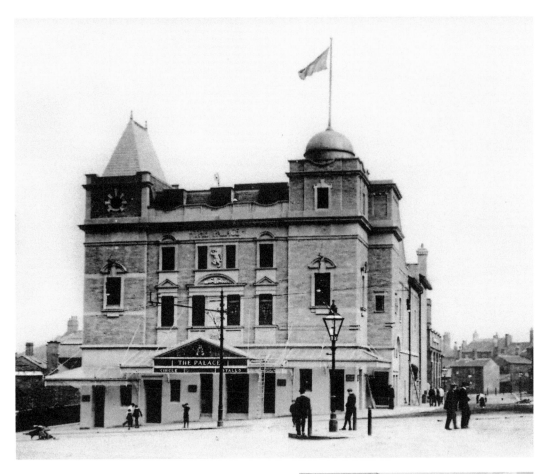

Palace Theatre I

Pictured here in May 1951. On 3 April 1911 escapologist Harry Houdini made the first of two visits to Huddersfield – at the Palace and later at the Empire. Another superb façade, originally built as a music hall by Horsfall & Sons in 1909 with ornate decorative plasterwork and a capacity of 1,614. The building was badly destroyed in a fire in January 1936 but was substantially rebuilt to an art deco design. It has seen life as Chicago Rock Café and a nightclub in recent years. Now it's being converted into student flats – with the superb façade fully preserved.

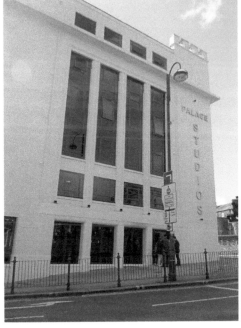

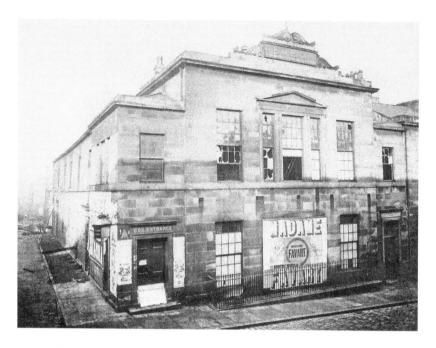

The Philosophical Hall, Ramsden Street

The Philosophical Hall, later the Theatre Royal, was in what is now the Piazza. It was a hotbed of political meetings from the 1840s to 1860s and the home of the Secular Sunday School and of a short-lived Republican Party. Charles Bradlaugh, political activist, British Republican and founder of the National Secular Society came to speak here in 1866 but was locked out of the hall and arrested for attempting to force an entry. The Piazza is in the new photo.

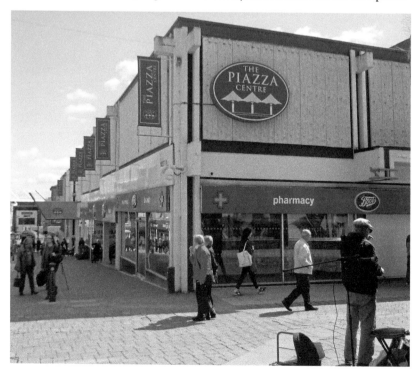

Palace Theatre II

Huddersfield's cinema history began in 1884 when the Hippodrome and Circus opened its doors. In September 1896 the first animated picture was shown at Rowley Empire 'by means of the theatrograph projection'. There have been twenty-one major cinemas in Huddersfield over the years. These included the Princess in Northumberland Street – a former woollen merchants opened in 1923 and closed in 1982. The last film was *Yanks* starring Richard Gere.

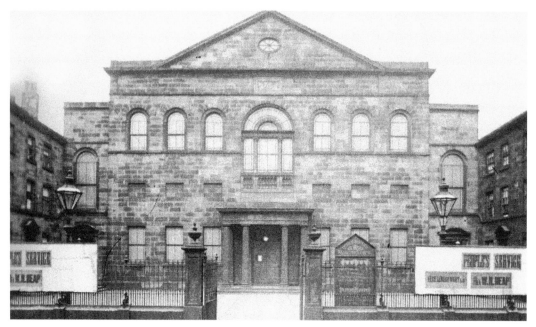

Lawrence Batley Theatre
Huddersfield's Lawrence Batley Theatre opened in 1994 and is named after Lawrence Batley, a local entrepreneur and philanthropist, who established a nationwide cash and carry chain. The building was originally built in 1819 as a Methodist chapel, once the largest Wesleyan chapel in the world. It stages dance, drama, comedy, music and exhibitions 'and is the base for Full Body & the Voice, a company focusing on the integration of disabled people into mainstream theatre'.

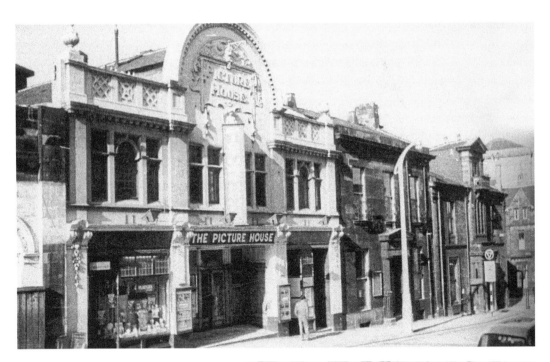

The Picture House, Ramsden Street
The town's first purpose-built super-cinema with its glorious façade in the mid-60s. It opened on Boxing Day 1912 with *The Red Ink Tragedy*, a silent short film of 1912 starring John Bunny and Flora Finch. In 1954 there were twenty-one cinemas in Huddersfield and the surrounding villages: Carlton at Birkby; Cosy Nook at Selandine Nook; Curzon in the town centre; Empire in the town centre; Excelda on Lockwood Road; Grand on Manchester Road; Lounge on Newsome Road Lyceum at Moldgreen; Majestic on Viaduct Street; Milnsbridge Palace; Picture House on Ramsden Street; Plaza at Thornton Lodge; Premier at Paddock Head; Princess on Northumberland Street; Regal at Moldgreen; Regent on Bradford Road; Rialto on Sheepridge Road; Ritz on Market Street; Savoy at Marsh; Tudor on Ramsden Street; and Waterloo at Waterloo. The lower image shows that entertainment was not just confined to the cinema; weather permitting...

August 2nd 1890

"Drop from the Clouds."

Belle Vue Gardens,
HUDDERSFIELD.
Proprietor JOHN PARKER

BANK-HOLIDAY!

Saturday, August 2nd.
GRAND

BALLOON
ASCENT and

PARACHUTE
DESCENT
OF
8,000 FEET
Through Space by Miss

CISSIE KENT
England's Lady Parachutist, and
LIEUT. LEMPRIERE,
The Well-known Æronaut,
Wind and Weather permitting.

Manager: Mr. Alec Payne, Fete Agent, 103, Stamford Street, London.

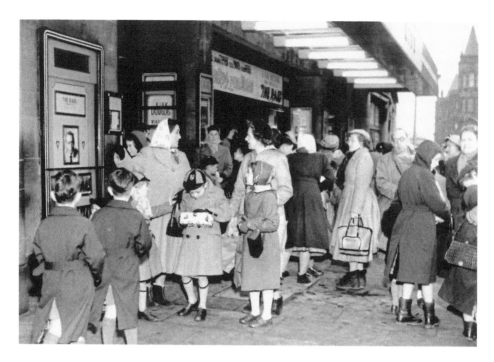

ICI Kids' Treat at the Ritz cinema

Just look at the faces on the children as they get their presents! The story of ICI in Huddersfield begins in 1915 with local chemical firm, Reid Holliday, merging with Levensteins of Manchester under the name British Dyes Ltd; they later became part of ICI and subsequently Astra Zeneca. The company manufactured eleven million tons of TNT at their site between Dalton and Leeds Road without incident. Also in 1915, LB Hollidays was set up to produce picric acid (2,4,6-trinitrophenol–TNP), used in munitions, at a rate of 100 tons per week – enough to make a million shells. After the First World War, Hollidays produced less volatile products such as dyestuffs. Picric acid emits a high-pitched whine during combustion in air, leading to its use in fireworks.

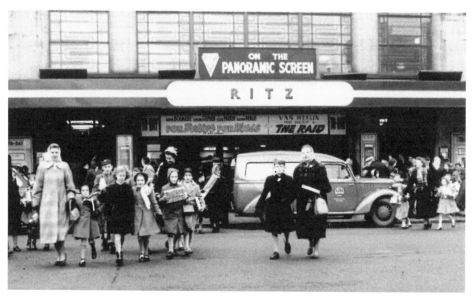

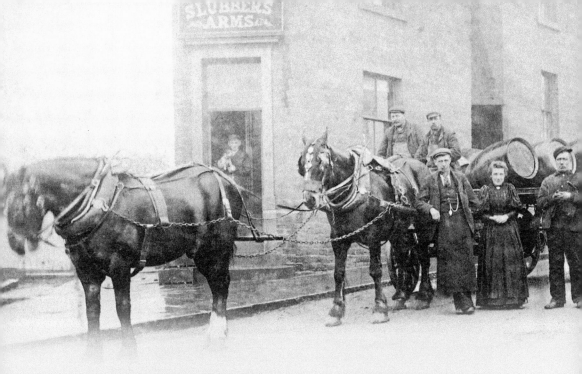

CHAPTER 4
Pubs & Hotels

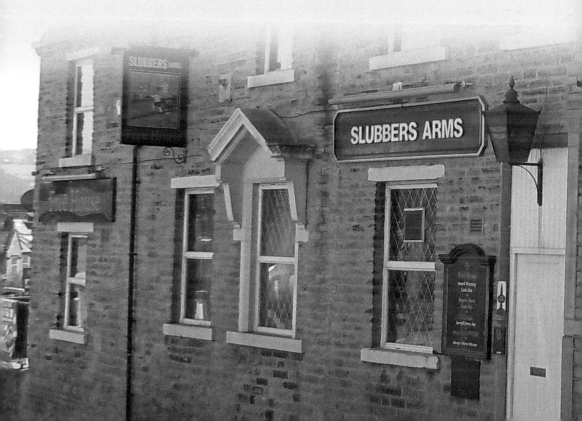

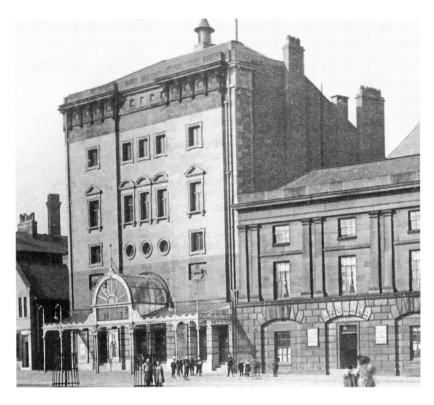

The Zetland and the Hippodrome

The Tudor is on the left when it was called the Hippodrome. The Zetland, currently closed, was at No. 29 Queensgate. The image overleaf shows The Slubber's Arms at No. 1 Halifax Old Road, in 1900. The pub's name celebrates the traditional skill of slubbing, the drawing out and twisting of fibre in preparation for spinning – 'visitors can read all about the process and other crafts. The Slubber's is as much museum as it is pub and no visit is complete without sampling a little of the local history that resides here'. It was founded as a beerhouse in 1853. The lady in the middle is Lucy Williams, the licensee in 1900.

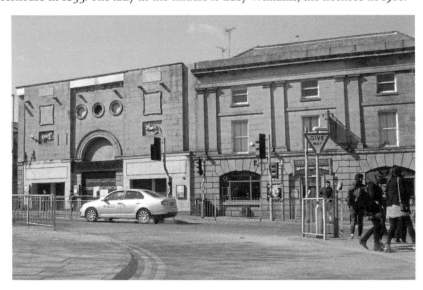

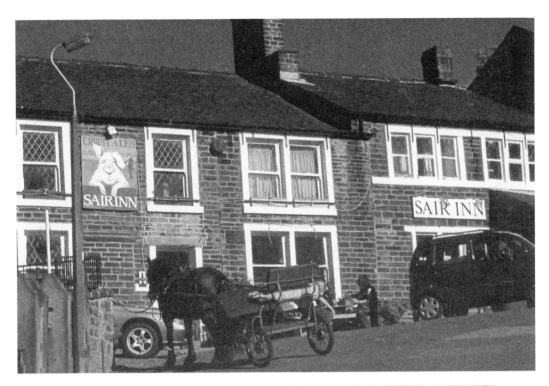

The Sair Inn

At No. 139 Lane Top, The Sair Inn is high up on the edge of the Colne Valley, home to the famous Linfit Brewery, which has been brewing for over thirty-three years. The pub dates back to 1700; the Sair was a nineteenth-century brew pub; brewing was started again in 1982 as the Linfit Brewery. 'The beers include Linthwaite Mild, Bitter, Enochs Hammer (approx 8.6%) and English Guineas Stout. The pub is generally viewed as being a typical English pub - so much so that Japanese businessmen came to the Sair to take photos so that they could reproduce the whole pub over in Japan!' There are a number of theories competing to explain this unusual name. Originally, it was known simply as The New Inn but later it took on the less simple t' Saah: a happy pig on the sign would suggest that 'saah' was really 'sow'; others say it is sour – as in a response to 'how's the beer?' Others still say it is after the name of an owner, John O' T' Saah, who lived near a stream and 'saah' means, onomatopoeically, a rushing sound. The modern image is of the Parish Pump – a much newer pub opposite St Peter's on Kirkgate.

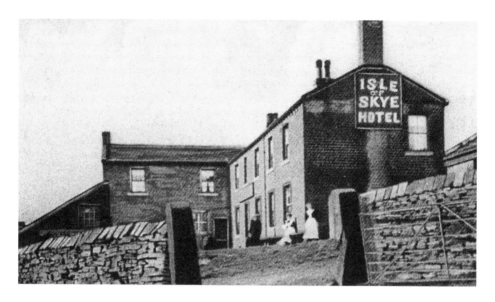

The Isle of Skye Hotel, Meltham Moor

Just up the road from The Isle of Skye is the Bill O'Jacks which was demolished to make way for the Yeoman Hay reservoir. But not before it was the setting for a grisly, as yet unsolved, murder. On 2 April 1832 a landlord and his gamekeeper son, Thomas and William Bradbury, were violently murdered at The Bill O' Jacks or The Moorcock, reported at the time as 'one of the most diabolical murders ever committed'. We learn of 'a scene of bloody carnage that sent shockwaves through the local community and beyond. According to witness accounts at the inquest, blood covered the floor, furniture, walls and stairs of the pub as if there had been a violent struggle'. 'The walls and flags streaming with gore' according to one colourful contemporary newspaper report. The lower picture is of a more modern pub: the Lord Wilson in King Street.

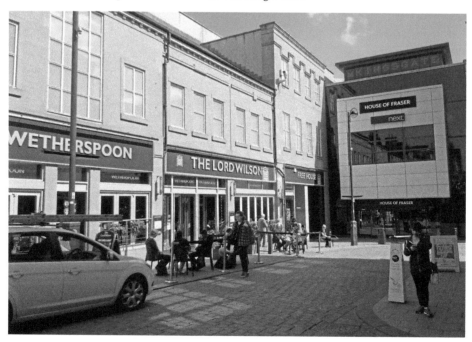

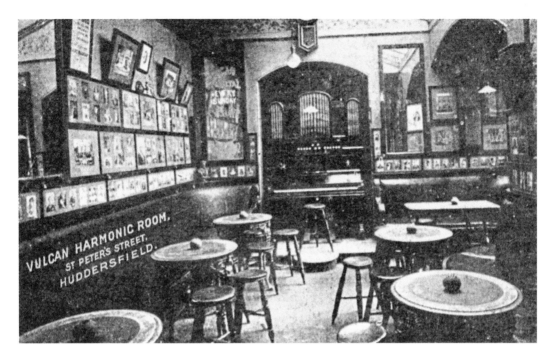

The Vulcan Inn and the Plough Hotel

The Vulcan at No. 32 St Peter's Street and the Plough Hotel in Westgate, rebuilt in 1917 and demolished in 1970. The Vulcan from 1851 gets its name from a large dray horse owned by brewer Joseph Cliffe. It was also known as the Harmonium Pub on account of the musical entertainment on offer there. George Formby appeared here as the 'Wigan Sprinter'.

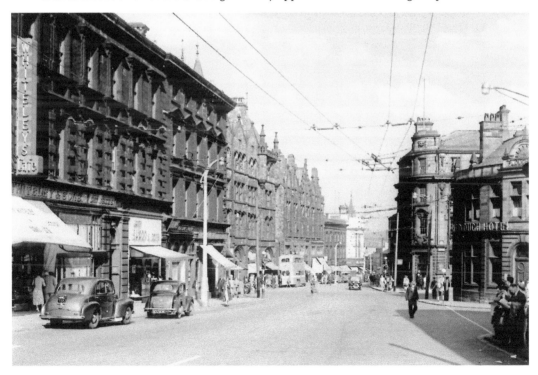

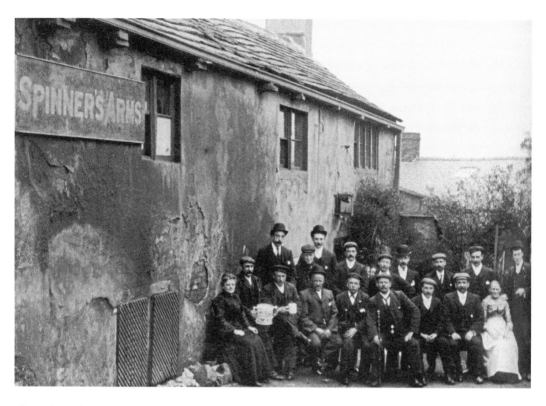

The Spinner's Arms, 1900
The Spinner's Arms in 1900 was at Lane, (Leeds Road), Bradley Mills; it was demolished in 1904.
Two families, the Brays and the Hudsons, were, between them, licensees for eighty-four years.
The new Spinner's Arms opened the same year.

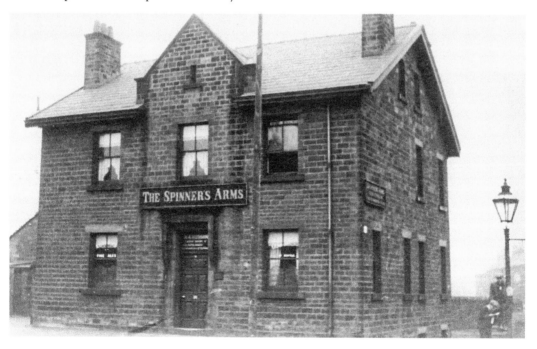

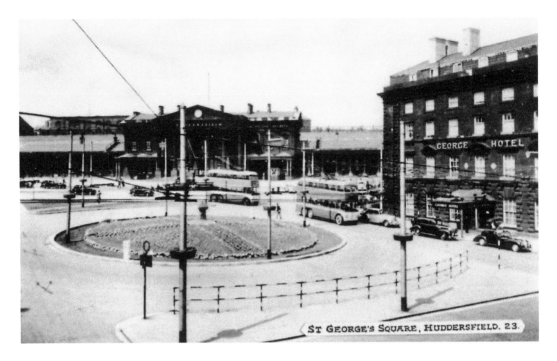

ST GEORGE'S SQUARE, HUDDERSFIELD. 23.

The George Hotel

A Grade II-listed building famous as the birthplace of rugby league football in 1895. This sixty bed hotel was built in 1851 and closed in 2013. It has an Italianate façade. On 29 August 1895 twenty-one Lancashire and Yorkshire clubs held a meeting here and, by a majority of 20 to 1, voted to secede from the Rugby Football Union to set up their own Northern Rugby Football Union which, in 1922 became the Rugby Football League. In 1892, charges of professionalism were levelled against rugby football clubs in Bradford and Leeds when they were found to be compensating players for missing work, even though the English Rugby Football Union (RFU) was allowing other players to be paid, such as the 1888 British Isles team that toured Australia.

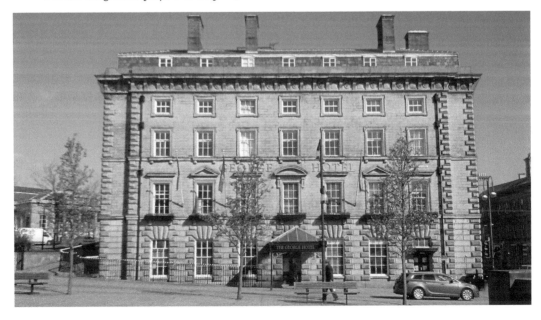

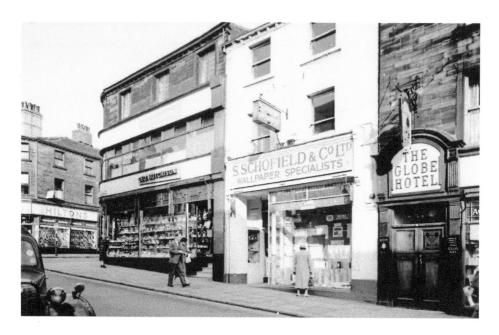

The Globe Hotel and The Ramsdens Arms

Like most towns and cities Huddersfield has lost a lot of its pubs, many in the name of 'progress', or shopping: The Ship on Bradley Street and on King Street, The Globe, The Royal Unicorn or The Burns Tavern were sacrificed for Kingsgate. The Painted Wagon on Market Street made way for Sainsbury's, the Pack Horse was demolished for 'The Pack Horse Centre'. Cross Church Street had The Minstrel, The White Lion and the Ramsden Arms. Queen Street could boast the brew pub, The Courthouse; The Crescent on Northumberland Street has gone along with the Dog & Gun. The Shoehorn on New Street is a thing of the past. The Ramsden Arms was at No. 5 Cross Church Street; it opened in around 1747 as a coaching inn. The pub is now called the Five Bar; previous names have included Flying Circus and Sharkey's.

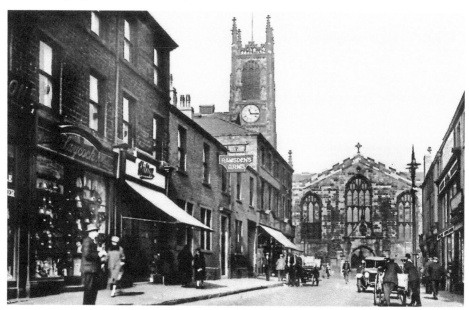

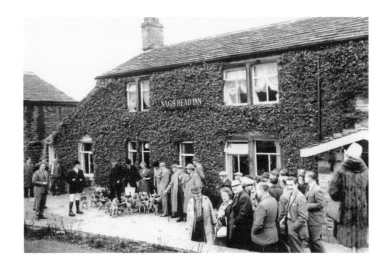

Hunt Meet at the Nags Head

At Fixby, Ainley Top, February 1964. Dating from the seventeenth century, the Nags Head Inn was originally two cottages and a barn converted into a coaching inn.

Here is a list of some pubs that have closed, in and around Huddersfield: Ashbrow, Bradford Road; Badger, Bradley Road; Bay Horse, Acre Street; Bridge Inn, Colne Road; Castle Hill, Castle Hill; College Arms, Queensgate; Crescent Hotel; Northumberland Street; Crimea, Cross Lane; Crosland, Dryclough Road; Dog & Gun, Brook Street; Friendly Inn; Green Cross, Old Wakefield Road; Grey Horse, Halifax Road; Griffin, Manchester Road; Hart, Cloth Hall Street; Jolly Sailor, Broad Lane; Little John, Keldregate; Market Tavern, Leeds Road; Northgate Inn, Northgate; Old Steam Pig, Newsome Road; Other Rooms, Queensgate; Post Office, Market Street, Milnsbridge; Primrose, Cross Lane; Primrose Hill, Queen's Mill Road; Red Lion, Lockwood Road; Rose & Crown, Meltham Road; Ship, Market Street, Paddock; Ship Inn, Queensgate; Spinners Arms, Leeds Road; Staff Of Life, Bankfield Road; Thornhill Arms, Bradford Road; Town Hall, Victoria Road; Warren House, Manchester Road, Milnsbridge; Waterloo, Wakefield Road; Wellington, Newsome Road; West Riding, Albion Street; Woolpack, Deighton Road; Woodman, Whitehead Lane.

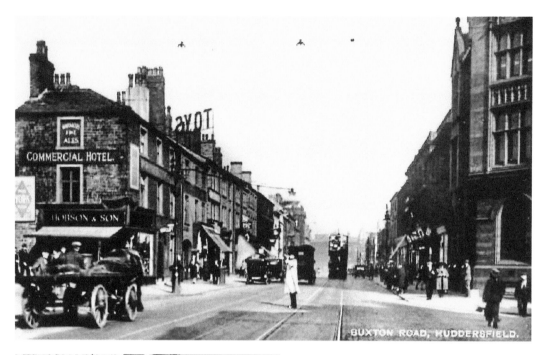

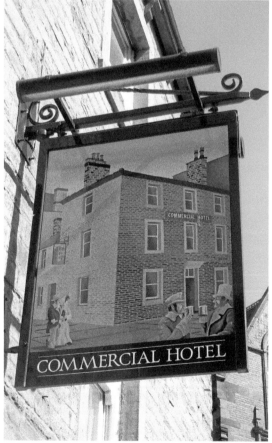

The Commercial Hotel
The Commercial is in New Street.
Quotation from the Sam Smiths Forum
website:

> What a busy place this is. But the
> Landlady is of the old school. She
> can serve 3 or 4 at the same time.
> Poetry in motion.

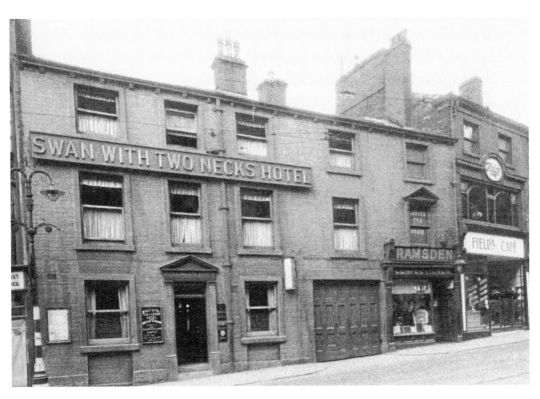

The Swan with Two Necks

The Swan with Two Necks in Westgate was rebuilt by brewers Bentley & Shaw as their flagship pub in 1933 and renamed the Royal Swan. It was originally built on the site of the Saddle and the Victoria Tavern. The delightful original name derives from the two nicks marked on the necks of royal swans to denote ownership. The Swan With Two Necks was originally situated next door to the Victoria Tavern which by 1890 was the Paragon Inn.

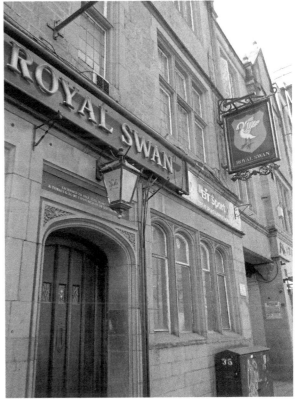

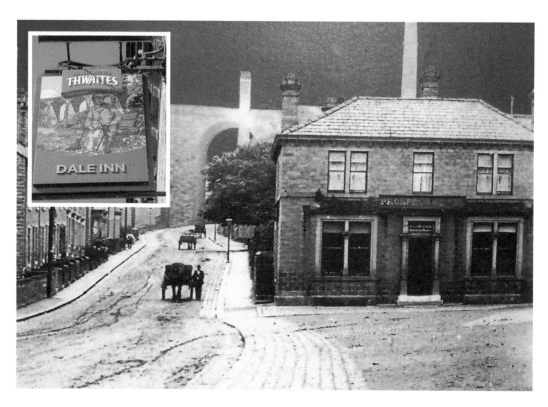

The Prospect Inn, Denby Dale
Now the Dale Inn, before that the Dalesman.

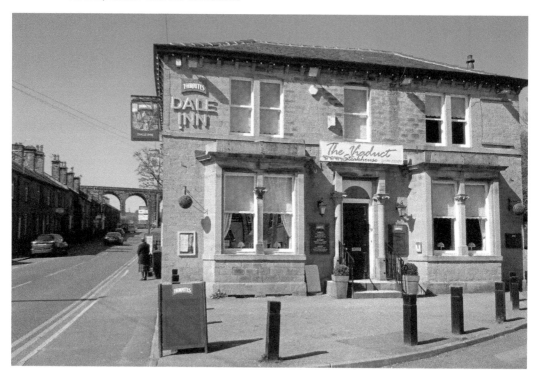

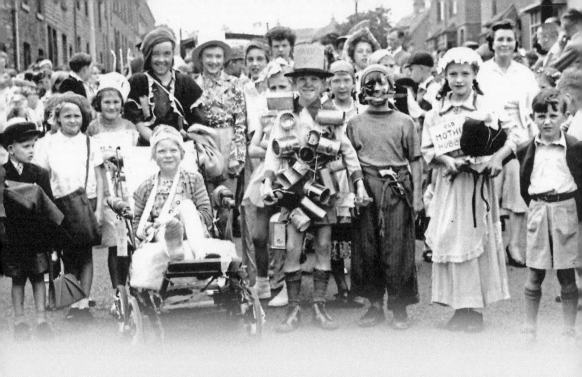

CHAPTER 5

Huddersfield People

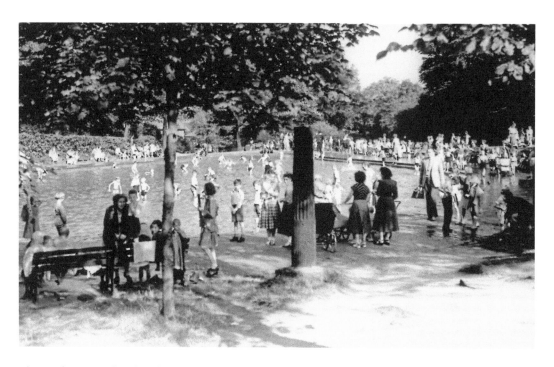

The Pool at Greenhead Park in 1955

The park opened in September 1884; grazing animals rubbed shoulders with the people of Huddersfield in the early days. The paddling pool has been a popular feature since the 1930s. The Petanque Club in the park looks to be just as popular. The image on page 53 shows a popular fancy dress competition at Ravensthorpe in June 1953, with some highly imaginative costumes including old Mother Hubbard, a fearsome pirate, 'Can Man' and a nurse with patient. The new picture is of the brightly decorated skateboard rink in the park.

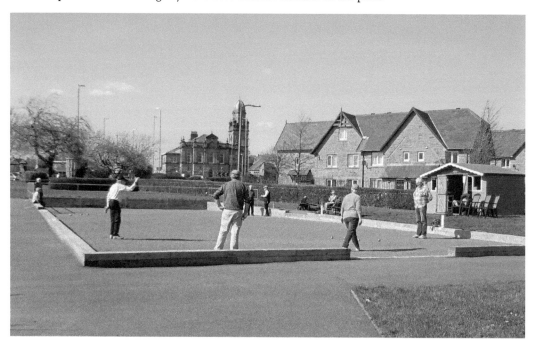

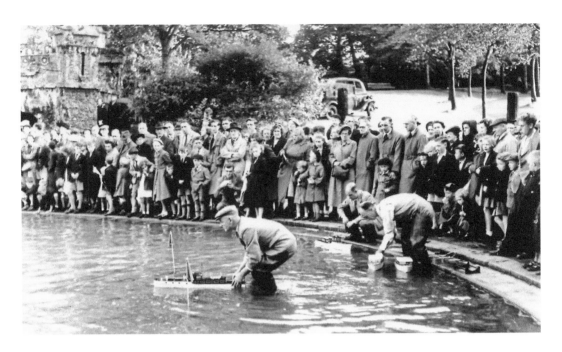

Greenhead Park model boat show August 1953

The largest of the park's five original lakes was filled in during the 1950s but was reinstated as part of the 2010 restoration; it is specifically designed to attract wildlife. Later additions to the park include the Boer War Memorial, unveiled in 1905, and the Great War Memorial in 1924. In between the wars the park was extended to its present size and saw the addition of two bowling greens, fourteen tennis courts, two putting greens; a café and sports changing rooms and conservatory.

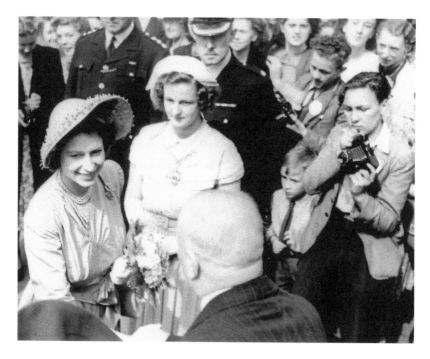

Princess Elizabeth with the Lord Mayor and Lady Mayoress

The royal visit took place on Thursday 26 July 1949 when the princess was twenty-three as part of a three-day tour of the old West Riding. The royal party was received on the steps of Huddersfield Town hall by the mayor, Alderman D. J. Cartwright and the mayoress; it proceeded to a Huddersfield Choral recital in the town hall before visiting 8,000 children at the Huddersfield Town Football Ground. The modern image shows the cross at the top of the War Memorial.

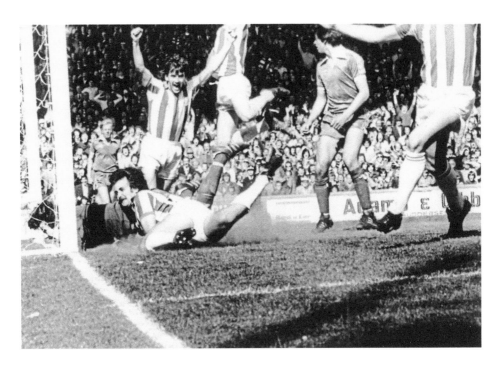

Huddersfield Town 2 Hartlepool 1

Ian Robins scores in the 2-1 victory over Hartlepool on 3 May 1980, the last game of the 1979/80 season in which Town scored their 100th and 101st league goals, the only time the club have achieved triple figures for goals in their history. They finished two points clear of Walsall to take champion's position and promotion to Division Three. Hartlepool finished 19th. The John Smith stadium in 2016 is in the new picture.

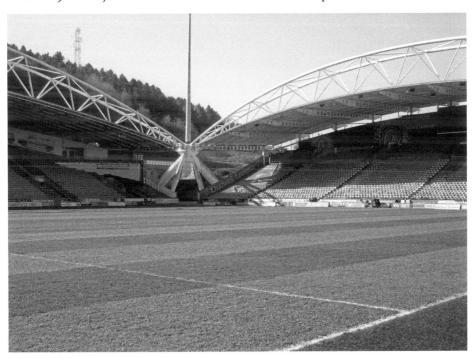

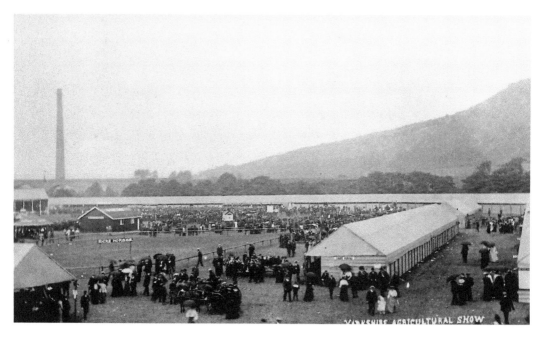

Yorkshire Agricultural Show 1904

The annual showcase of the Yorkshire Agricultural Society founded in 1837. The first show was held in 1838 at Fulford Barracks in York when police used their batons on the large numbers of visitors when they began to force their way in without paying. The show was originally a peripatetic event moving to various places around Yorkshire until 1950. Lower image shows Punch and Judy, July 1959.

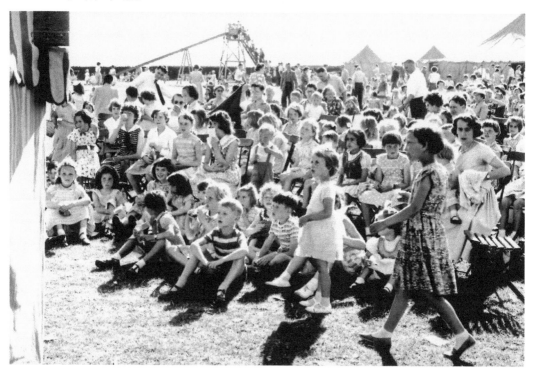

The Miniature Railway in 1959

Volunteers from the Huddersfield Society of Model Engineers run the current miniature railway which was opened in Greenhead Park in 2000. Live steam locomotives run along the 1/3 mile track. Real train at Huddersfield station in the new photograph.

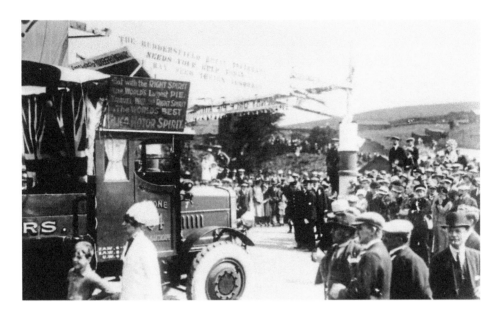

Denby Dale Infirmary Pie sampling

Baking huge pies in Denby Dale began in 1788 to celebrate the recovery of George III from a bout of insanity. To date, ten pies have been made at nine pie festivals: the second in 1815 marked the end of the war with France and the defeat of Napoleon; in 1887, a pie that was baked to celebrate the Golden Jubilee of Queen Victoria went off and was buried in quick lime – a replacement pie, the 'resurrection' pie, was later baked; the sixth pie was baked in 1896 to celebrate the fiftieth anniversary of the repeal of the Corn Laws; the seventh, pictured here, the Infirmary Pie, raised money in 1928 to endow a cot at Huddersfield Royal Infirmary; the eighth pie celebrated four royal births in 1964 and raised money for a village hall, the Pie Hall; the 2000 Pie weighed thirteen tons and celebrated the new millennium. The men who made the oven for the Infirmary Pie are in the lower photograph.

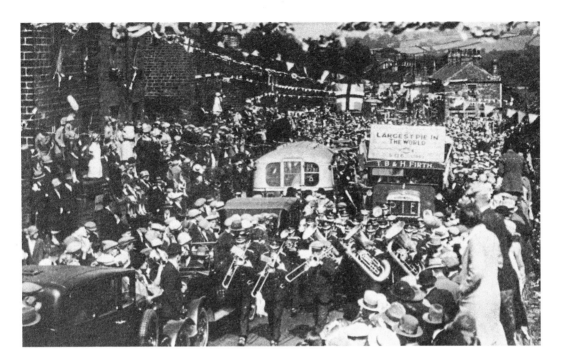

1928 Infirmary Pie

Processing along the High Street, and the ladies who did the baking – eighteen of them and five butchers. Here is the recipe: four bullocks (600 lb of beef), 15 cwt of potatoes, 80 stone of flour for the crust, 2 cwt of lard, 2 stone of baking powder = 100 cubic feet of pie, enough for 20,000 people to have nearly ¼ lb each. It took a week to cook the meat which was frozen while the potatoes boiled; the pie then cooked for thirty-six hours. Price: one shilling a head; £1,062 3s 5d was eventually presented to Huddersfield Royal Infirmary.

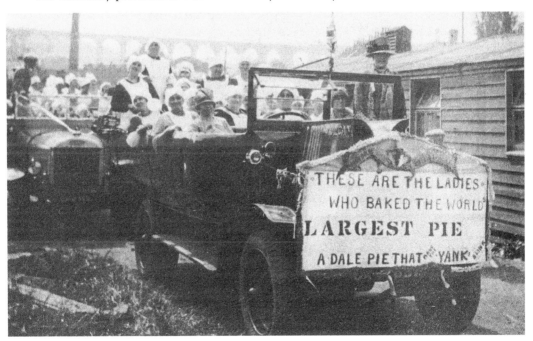

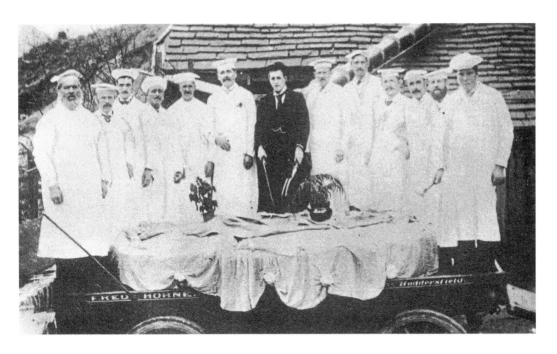

The 1896 Repeal of the Corn Laws Jubilee Pie with Servers

To make one of equal magnitude at home you will need 1,120 lb of beef, 180 lb of veal, 112 lb of mutton, and 60 lb of lamb; 20 stone of flour, 24 lb of lard, 24 lb of butter and 30lb of suet along with fourteen horses to pull what was a 1 ton 15 hundredweight monster of a pie. The lower photo shows the pie dish used in 1887 and 1896; it was scrapped in 1940. The 1887 Golden Jubilee Pie caused a near riot when the 2,000-plus crowd broke down the barriers and attacked the pie; they were only deterred by the dreadful smell, indicating clearly that the pie was off.

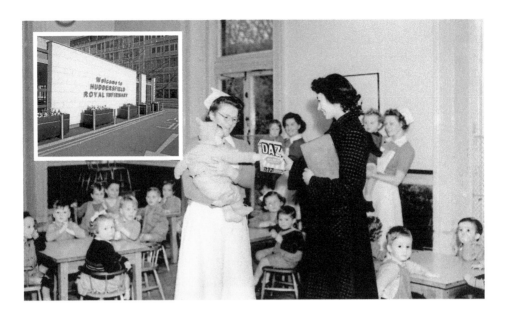

Daz Publicity Shot 1953 and Unlicensed Drug Production

Daz comes to Huddersfield Royal Infirmary. Daz was launched in 1953, manufactured by Procter & Gamble. The Royal Infirmary opened in 1965; since 1964 it has been home to a highly prestigious 'unlicensed pharmaceutical' operation, 'Huddersfield Pharmacy Specials'. It produces creams, liquids for injections and many other crucial potions and pills, producing life-saving pharmaceuticals not just for Huddersfield but for hospitals across Yorkshire and beyond. The site only manufactures so-called 'unlicensed medicines', which are specific bespoke products specially requested by doctors or pharmacists, or else licensed adult drugs repurposed for use in children. The site now employs over fifty staff in a purpose-built unit and produces more than 21,000 syringes of drugs a year. In 2014 over half a million packs of tablets, capsules, injections, creams and ointments were produced with a further 160,000 units of oral and topical liquids, creams and ointments annually. The lower photo shows the Royal Infirmary from the air.

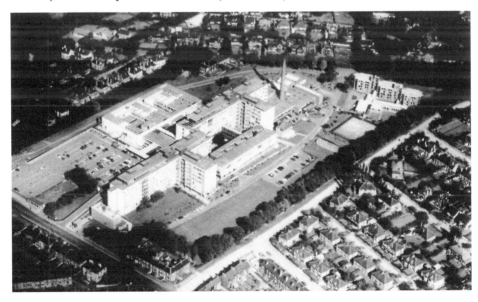

Greenhead Horse Show

A wet day in July 1953 with the War Memorial in the background. Horse and carriage rides have recently been reintroduced in the park on the belvedere below the War Memorial which are provided by Rising Sun Farm in Holmfirth. A typical Huddersfield domestic scene shot by local photographer forms the lower picture.

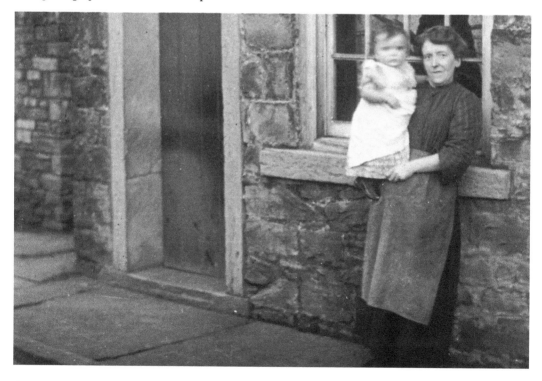

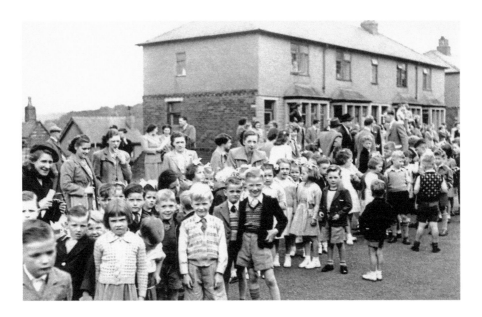

Primrose Gala Day, July 1953, and 'fishing'

Fishing at the Liver carnival in 1958. According to Daniel Defoe (1660-1731), writing in his *A Tour Thro' the Whole Island of Great Britain,* the beer here is the best:

> the first town it [the River Calder] comes near of note is Huthersfield, another large cloathing place ... Huthersfield is one of the five towns which carry on that vast cloathing trade by which the wealth and opulence of this part of the country has been raised to what it now is, and there those woollen manufactures are made in such prodigious quantities, which are known by the name of Yorkshire Kersies ... there is a market for kersies every Tuesday. Nor, as I speak of their manufactures, must I forget that most essential manufacture called Yorkshire Ale, which indeed is in its perfection here.

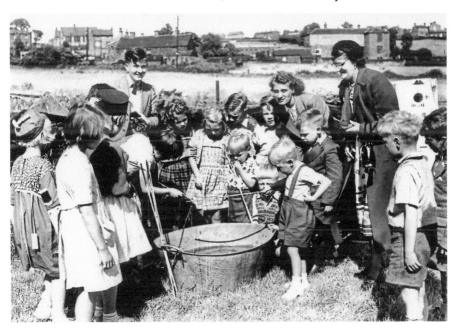

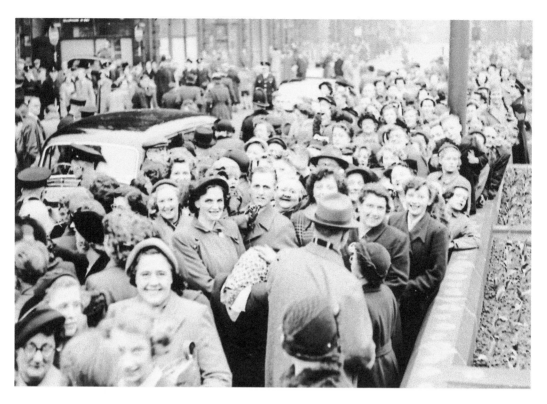

Waiting for Princess Margaret, April 1953

Princess Margaret was a regular visitor, she came to Huddersfield in 1953, 1958, 1967, 1970, 1973 and 1992. In November 1958 she opened the three schools at Salendine Nook: the Secondary Modern, Huddersfield High School for Girls and New College – all built at a cost of £1 million.

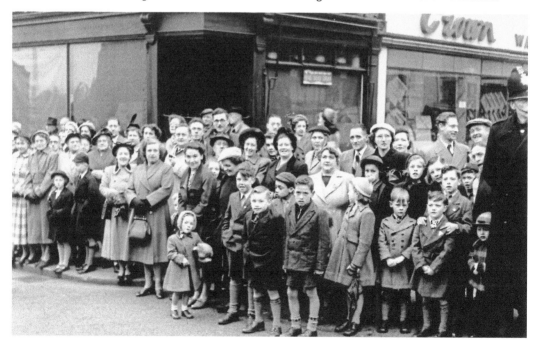

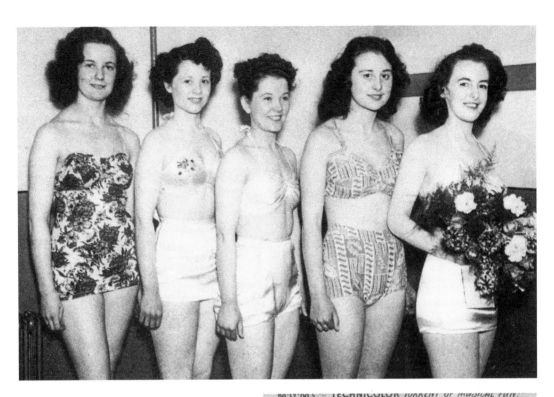

'Neptune's Daughter' Contest

A beauty contest held at the Ritz in April 1950 when such competitions were deemed appropriate. Prizes included a bouquet of seasonal flowers, a month's free pass to the cinema for two, a box of fruit squashes and a home perm kit. *Neptune's Daughter* is a 1949 musical romantic comedy film starring Esther Williams.

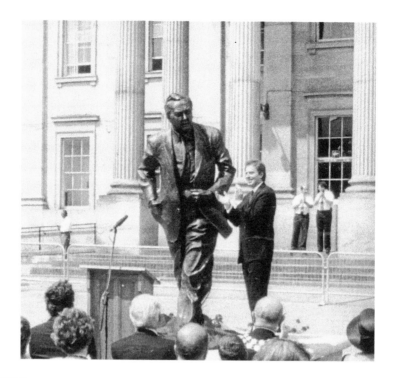

Harold Wilson

The bronze statue of Huddersfield-born Sir Harold Wilson, Prime Minister from 1964–1970 and from 1974–1976, stands in front of the entrance to Huddersfield's impressive railway station. James Harold Wilson, Baron Wilson of Rievaulx, KG, OBE, PC, FRS, FSS is the subject of a number of conspiracy theories including him having been a Soviet agent (a claim that MI5 investigated and found to be false), and Wilson being the victim of treasonous plots by conservative elements in MI5, claims made by Wilson himself. Look out Jeremy Corbyn!

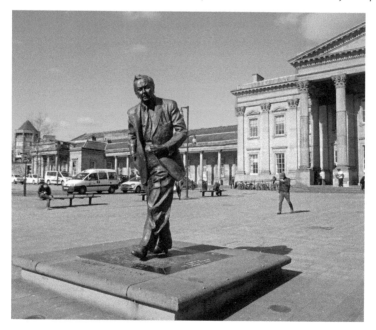

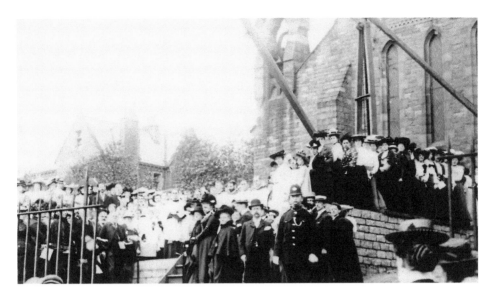

Laying the Foundation Stone at Moldgreen Church and St Peter's Church

The church is Christ Church in Brook Street. The 1818 fire at Atkinsons Mill, Colne Bridge, in which seventeen girls between the ages of nine and eighteen died, impelled Richard Oastler of Fixby Hall to act: the girls had been locked in the mill by the owner while they worked the night shift. At a meeting in Huddersfield in 1831 Oastler proposed a ten hour working day for five days and an eight hour working day for Saturdays. Oastler led a march to York in support of the '10 Hour Bill'. The Factory Bill became law in January 1834 banning the employment of children under nine years, that children under thirteen should work no more than a forty-hour week and should have two hours schooling per day, that the under eighteens should work a maximum of sixty hours per week with no night work, and that a regulatory body should be set up to enforce the law.

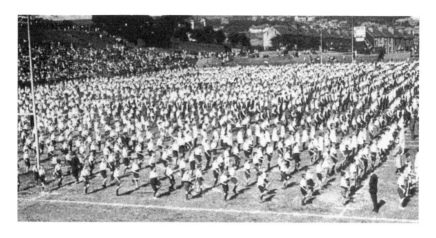

Fartown Grounds

A magnificent shot taken in the late 1920s. Both Huddersfield's Rugby League team, now the Huddersfield Giants, played at the St John's Ground (from 1878 to 1992) as did the Yorkshire County Cricket Club. The ground was originally known as the St John's Ground, after Huddersfield St John's Cricket Club – its original occupants in 1868; it was previously owned by the proprietor of the George Hotel in Huddersfield. In 1875 St John's merged with Huddersfield Athletic Club to form the Huddersfield Cricket and Athletic Club – the name of the stadium was then changed to Fartown Grounds. The cricket field was once considered to be the finest wicket in Yorkshire. Fartown is nowadays the location of Huddersfield's Sikh temple.

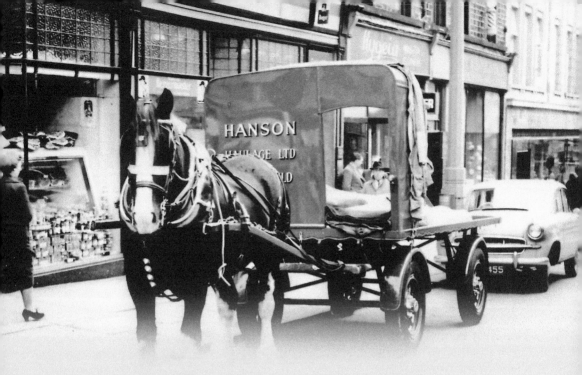

CHAPTER 6

Transport & Disaster

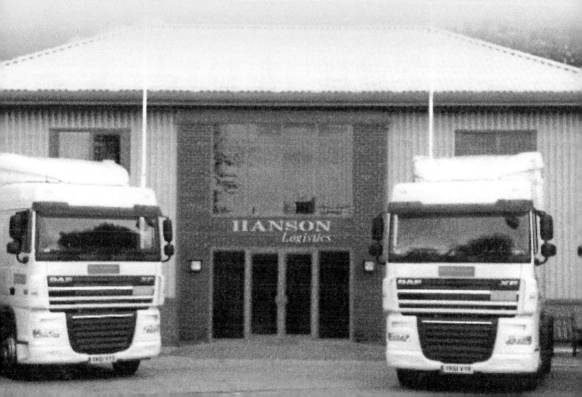

Royal Cycle Escort

...for the visit of Princess Elizabeth, July 1949. The lower picture shows the A641 road under the M62 towards Brighouse. Page 71 shows a Hanson's horse and cart. The Hanson family's move into to the haulage business from being Yorkshire farmers begins with the pioneering Mary Hanson in 1848 who perceptively identified a need for a regular transport service taking wool from Huddersfield to the local cottage weavers and bringing their finished textiles back to the town. Her local service gradually developed to three times weekly using the farm's horses and wagons and working as far afield as Manchester and Leeds. The successful business soon expanded to include carrying coke and coal for Longwood Gas Company, and household removals.

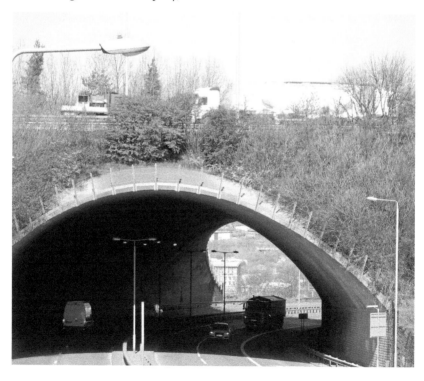

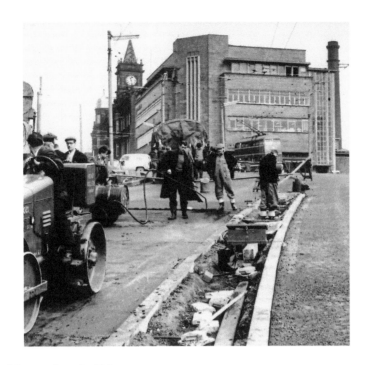

Laying Cables at Chapel Hill in 1973

In 1913 Hanson's purchased a steel-tyred Foden steam lorry for furniture removals while in the following year a similar vehicle with solid rubber tyres was acquired; horse wagons and vans continued to be employed up to 1939 when 400 working horses were still in service. Horses were trained for the Territorial Army before and after the First World War and in 1919 a fleet of charabancs was bought; a year later a full bus and coach service began. In 1920, Thomas Darwens, wedding and funeral car hire, was acquired and later the old cars were replaced with Rolls-Royce cars; this limousine service continued for fifty years. In 1935 Hanson's Buses Ltd, was established. Hanson's still trades today as Hanson's Logistics in Ashgrove Road. Road works are, of course, just as common – the lower picture depicts works just off Market Place in 2016.

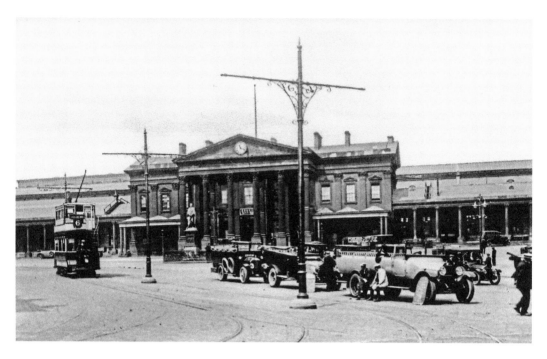

'A Stately Home With Trains In It'

Huddersfield railway station, a Grade I-listed building, was described by John Betjeman as 'the most splendid station façade in England', and by Sir Nikolaus Pevsner as 'one of the best early railway stations in England'. The Station Hotel was opened here in 1853 but repurposed as the booking hall in 1885.

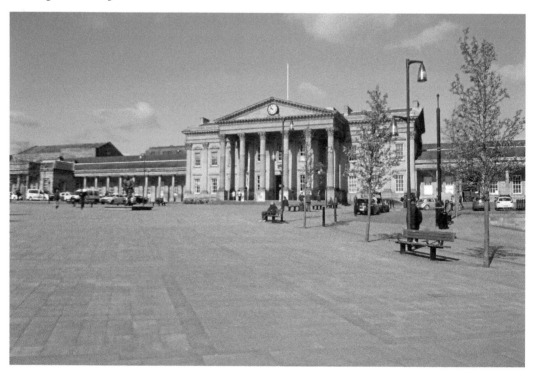

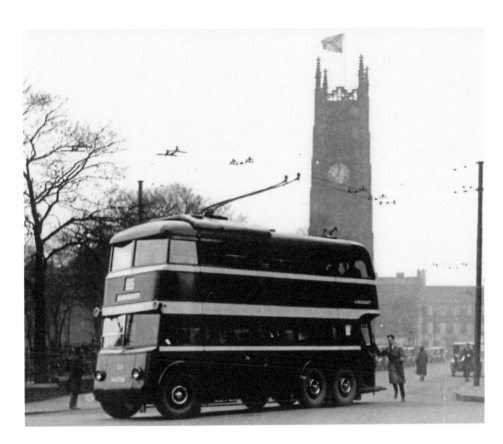

Catching the Bus ... Just

Controversial bus gates became operational on 1 February 2016, enforced using camera technology which captures the registration number of vehicles that are not authorised to use the bus gates: vehicles allowed to use the bus gates were local buses, hackney carriages and cycles. The fine was £60 reduced to £30 if paid within fourteen days of the fine being issued. The bus in the lower picture was unlucky, to say the least – a spectacular crash at Dod Lea terminus 1967.

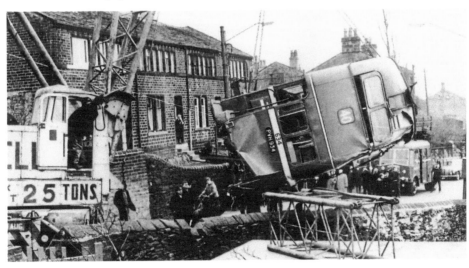

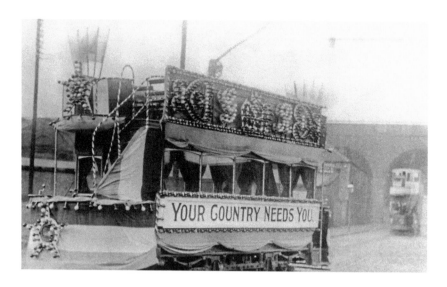

The Recruitment Tram

One of three special trams reported in the *Halifax Courier Weekly* of 26 September 1914:

> A novel recruiting campaign involving three illuminated trams was organised by the Civilian Recruiting Committee to conduct a recruiting tour of the Calder Valley ... to help with Lord Kitchener's appeal for more men. All were studded with fairy lamps, gay with bunting, and flashed appeals for service such as 'Serve your King', 'Your Country Needs You' and 'Now or Never'.

Another spectacular crash: Bradley tram crash happened on 22 April 1904. Other tram disasters include: 3 July 1883, when a tram en route to the town centre from Lindley, as it was descending the gradient in Westgate it ran out of control and was derailed as it rounded the curve into Railway Street – seven people died and twenty-eight were injured. On 3 June 1891, a fire box shell in a steam engine exploded while it was stopped at Longroyd Bridge killing one youth and scalding the driver. On 28 June 1902, an electric tram lost control in Almondbury, crashing into the Somerset Arms killing three people and injuring several others.

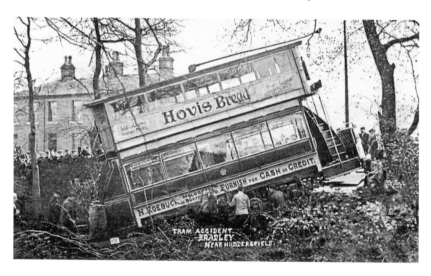

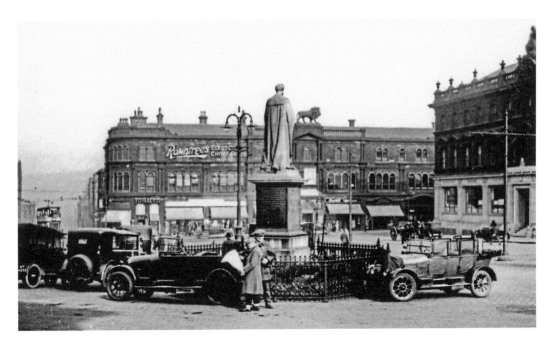

St George's Square

St George's Square and the surrounding buildings came into being between 1846 and 1859 as part of the Ramsden family's ambitious plans to create a 'New Town' after the arrival of the railways in Huddersfield. The Ramsdens spotted the commercial value of the land fronting the station and ensured that the buildings populating the square were suitably upmarket and prestigious.

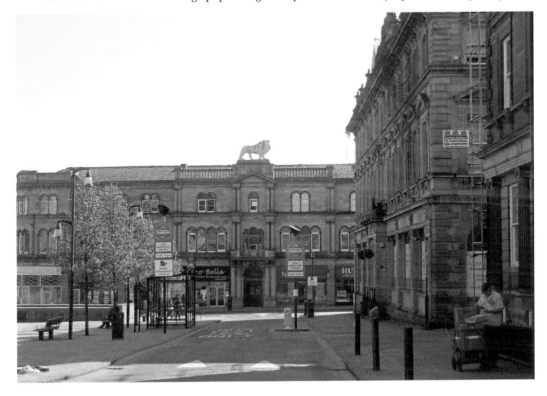

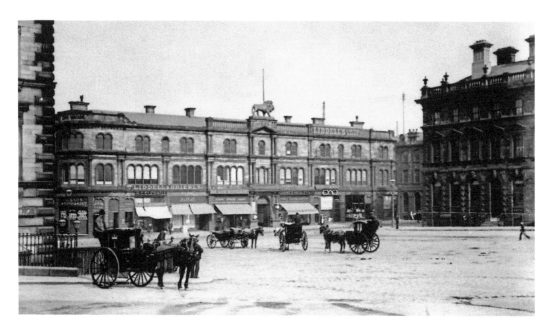

Horse-Drawn Taxis at St George's Square

The layout of the square has changed frequently over the years with developing transport systems, and to accommodate horse drawn carriages, trolley buses and taxis. It is home to some of the town's finest buildings including The George Hotel, Lion Chambers, Britannia Buildings, Tites Building and Huddersfield Railway Station. As we have seen, the statue of Huddersfield's most famous son, Harold Wilson, Lord Wilson of Rievaulx (1916–1995) stands proudly here. Local sculptor, Ian Walters created the work which was unveiled on 9 July 1999 by Tony Blair.

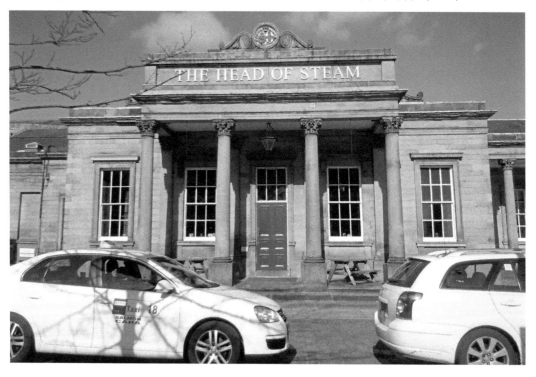

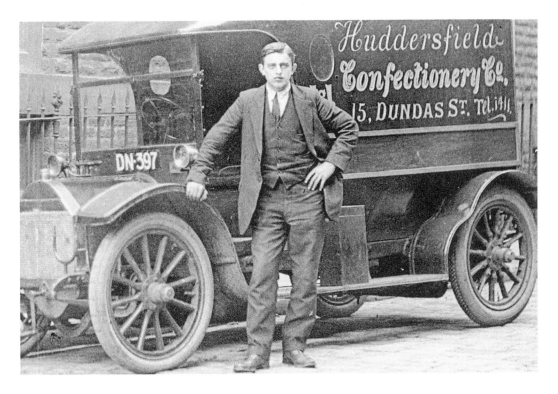

Huddersfield Confectionery Co.

This may well be Walter Thomas Hawkins who lived at No. 21 Imperial Road, Edgerton, Huddersfield. Hawkins was a 'Belt Food Manufacturer and Wholesale Confectioner', who, according to the *London Gazette,* carried on business at Chapel Hill at Dundas Street. He died on the 30 June 1912. A belt food manufacturer simply made food conveyor belts for food handling. In the lower picture we can see the Infirmary Pie being transported along Denby Dale High Street.

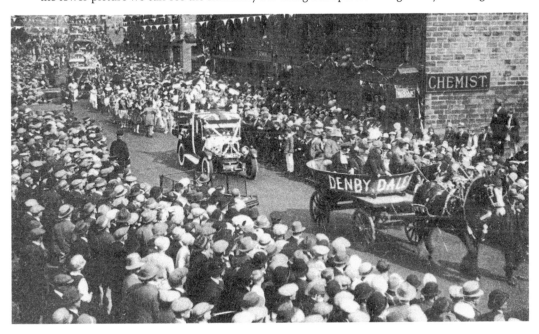

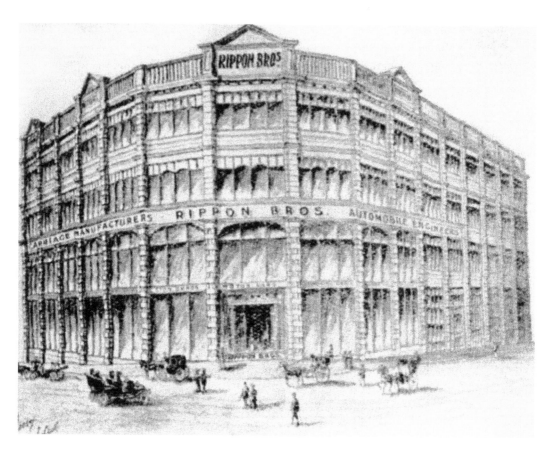

Rippon Brothers

Showroom and works on the corner of Viaduct Street and Fountain Street. World-famous car makers Rippon Brothers started up in the 1850s with horse-drawn vehicles but embraced the motor car with a fine line in bodies for luxury vehicles. One of their Rolls-Royces cost £1,850 in 1922; they were taken over in 1970.

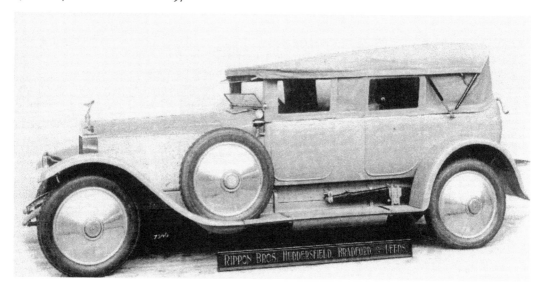

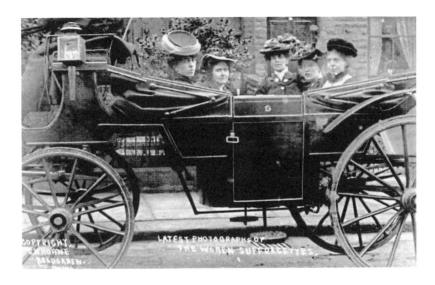

Not Smiling for the Camera and Huddersfield Suffragettes

Huddersfield is arguably Yorkshire's most important centre for suffrage history, all based around two savagely fought by-elections in 1906–07. In 1906 Emmeline Pankhurst came to speak in the town at the ancient market cross: her Women's Social and Political Union (WSPU) movement pledged to oppose all Liberal candidates. Other suffragettes descended on the town, chalking the pavements and bill-posting the streets. The government were panicked into releasing jailed suffragettes. Annie Kenney, and others freed from Holloway, hurried north by train and 'exploded into the by-election' where they were greeted by a crowd of 4,000. Annie Kenney urged 'young women of the town to... join the movement' and by the end of the meeting no fewer than fifty local women signed up. The Huddersfield WSPU branch was formed and became one of the most dynamic and active in the country. The lower photo celebrates a day out from Lepton for the girls, with nosey neighbour to the top left.

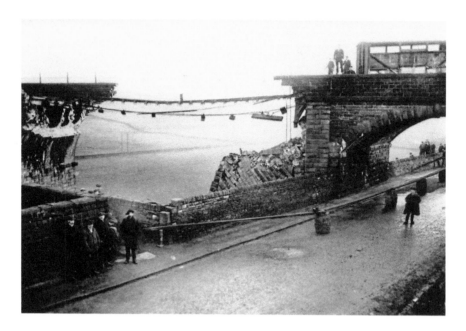

Good Friday 1905 Railway Crash I

Driver error was attributed as the cause of this fatal crash when a signal was passed at danger, leading to a head on collision, derailment and telescoping of carriages. There were two fatalities and thirteen passengers were injured. According to the Accident Returns the Lancashire & Yorkshire 2.20 p.m. train from Mirfield was coming into Huddersfield Station on the up south line and was hit by a London and North Western engine with two empty coaches and a van, which had started in error from the up main line in the station. Two passengers on the Lancashire & Yorkshire train were killed and nine injured including the fireman and the shunter, along with the driver and fireman of the Lancashire & Yorkshire engine.
http://www.railwaysarchive.co.uk/docsummary.php?docID=2223

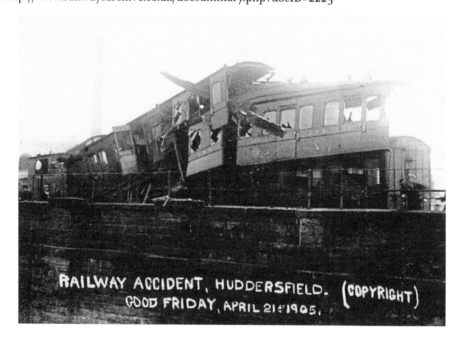

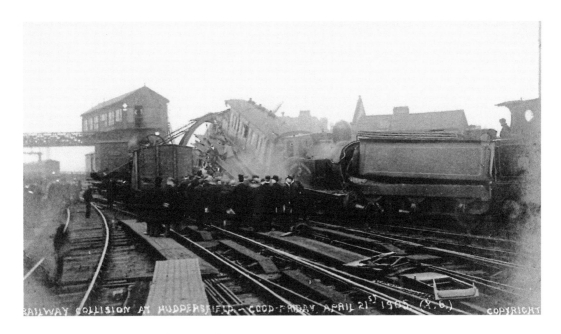

RAILWAY COLLISION AT HUDDERSFIELD - GOOD-FRIDAY. APRIL 21 1905. (X.6.) COPYRIGHT

Good Friday 1905 Railway Crash II

Another serious accident happened on 30 March 1889: this was FA Cup Final day in which Preston North End were playing Wolverhampton Wanderers at Kennington Oval, and the day of the University Boat Race. A Liverpool to Kings Cross train ran down the gradient towards Penistone Station when the locomotive jumped the points at Huddersfield Junction signal box: the front coach was smashed in and coaches two and three toppled onto their sides. One person was killed and many injured. Those with more severe injuries were taken to the Wentworth Arms Hotel where the billiard room was converted into an operating theatre. A further crash was averted by the prompt action of the signalman in Huddersfield Junction box.

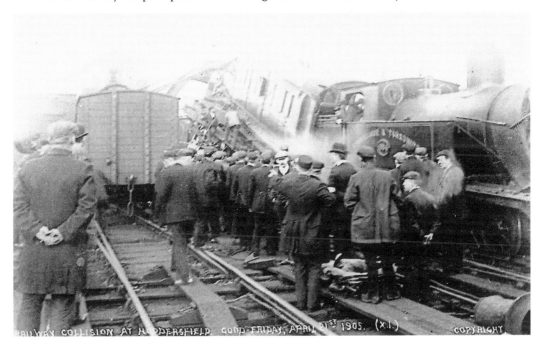

RAILWAY COLLISION AT HUDDERSFIELD GOOD-FRIDAY. APRIL 21ST 1905. (X.1.) COPYRIGHT

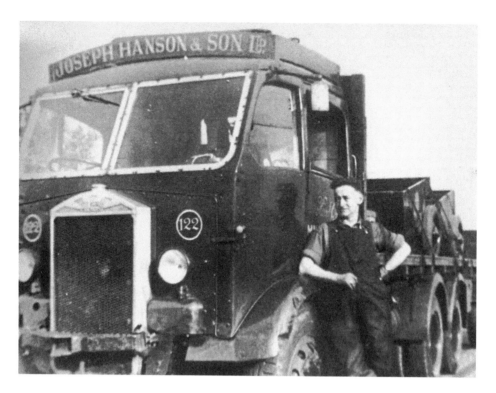

Joseph Hanson & Son

Lorry driver Albert Bailey stands outside his cab in the '30s; he would have driven to London three times a week with his loads. Modern M62 road transport in the picture below.

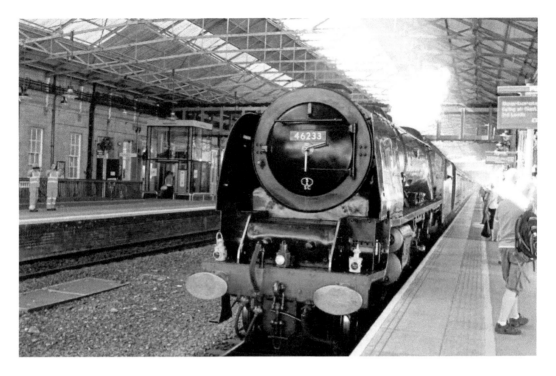

The Scarborough Flyer in 2013

The restored and magnificent *Duchess of Sutherland* at platform 4 at Huddersfield Station on its way through to Scarborough, via York. The lower image shows the splendid mural at the station.

The M62

Two shots of this motorway that is so essential to Huddersfield's economy. The top photo shows the Brighouse road going under the M62. The M62 is 107 miles long (172 km), connecting Liverpool and Hull; it is part of the Euroroutes E20 (Shannon to Saint Petersburg) and E22 (Holyhead to Ishim in southern Russia). It was first proposed in the 1930s, and eventually opened between 1971 and 1976; average daily traffic flow is 144,000. The section between Junction 18 (with the M60) and 29 (with the M1) through Greater Manchester and West Yorkshire is one of the most congested roads in Britain.

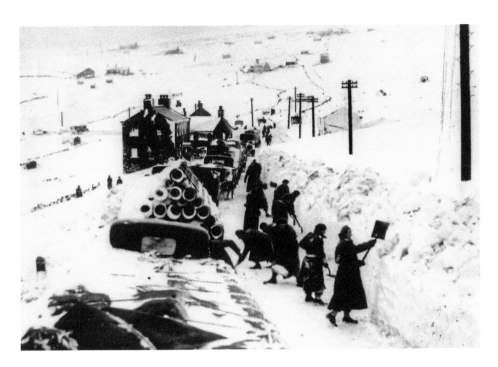

Polish Troops Help Clear the Snow on the A62 at Standedge

Cannon Hall Park at Cawthorne was home to almost 1,000 allied troops from Eastern Europe during and after the Second World War. The park was originally requisitioned by the War Office in 1940 as a tented camp to house British troops evacuated from Dunkirk but from later in 1940–49 it was home to units of the British, Canadian and Polish armies. At the end of the war, some 250,000 Free Polish Armed Forces troops, in what became Western Europe and the Middle East, had their homes in such camps around the UK.

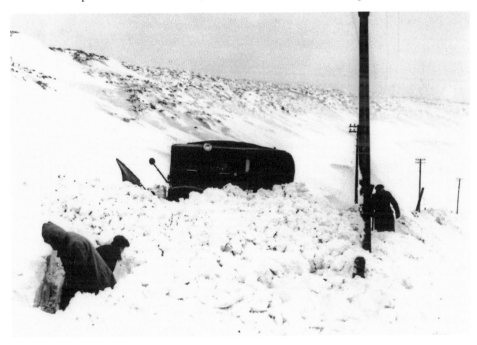

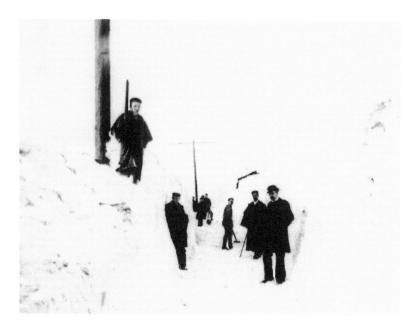

Digging to Holme Moss January 1952

Many could not return to Poland because their homes in the east of their country had been ceded to the Soviet Union under the Yalta Agreement, or because they feared living under Communist rule in Poland, having already experienced the horrors of the Soviet gulags. In May 1946 the British set up the Polish Resettlement Corps (PRC), a non-combat unit of the British Army, designed to facilitate the Poles' transition into British civilian life. Around 14,000 members of the Free Polish Armed Forces signed up with the PRC. Cannon Hall was one of approximately 300 camps around Britain housing the Poles, many of whom found work in the local textile mills. Many also undertook additional studies to achieve O and A levels in a variety of subjects; they also learned English language, laws and customs to help them integrate and perfected skills from agriculture and the mining industry. They provided a real benefit to the UK economy and were a bonus to British society.

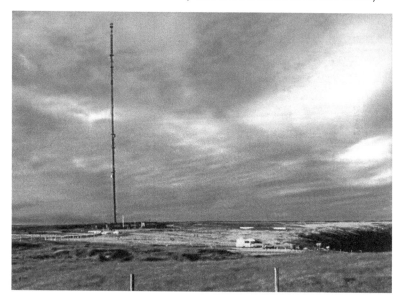

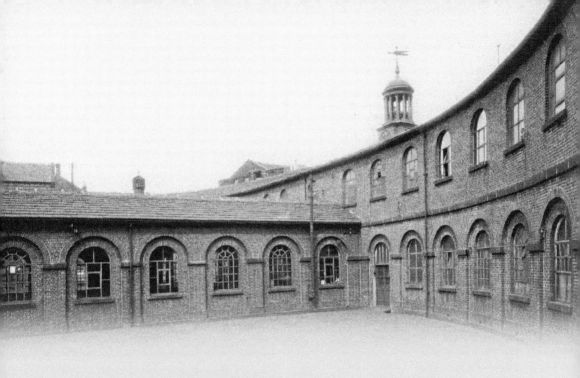

'Icons' In & Around Huddersfield

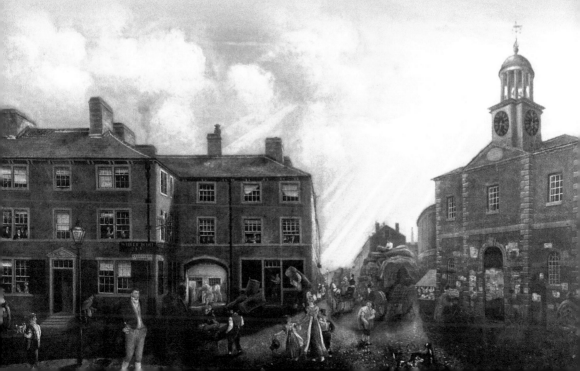

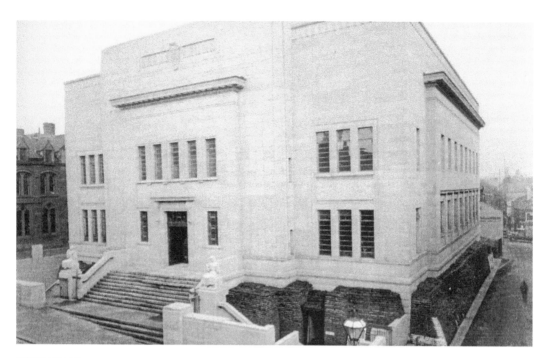

Huddersfield Library and Art Gallery

In 1929, the Town Council sacrilegiously demolished the Cloth Hall with plans to replace it with a public library but the plans for the library went nowhere and the site was leased to Union Cinemas in the mid-1930s, who built the Ritz Cinema, later the ABC. The library and art gallery shown here opened in 1940; the Art Gallery boasts works by Bacon, Lowry, Sutherland and Moore.

The Cloth Hall on page 89 is emblematic of Huddersfield's textile prosperity in the nineteenth and early twentieth centuries. It was built in 1766 by Sir John Ramsden and was the largest building in Huddersfield at that time, reputedly housing 2,000 clothiers. Unlike all other major buildings in the town, it was made of red brick; initially it was a single storey structure, but a second storey was added in 1780. In 1837, *White's Directory of the West Riding* described it as follows:

The light is wholly admitted from within there being no windows on the outside by which construction security is afforded against fire and depredation. The hall is subdivided into streets and the stalls are generally filled with cloths lying close together on edge with the bosom up for inspection ... The hall is attended by about 600 manufacturers and many others have ware-rooms in various parts of the town. The manufactures of Huddersfield are principally woollens consisting of broad and narrow cloths, serges, kerseymeres, cords etc. and fancy goods in an endless variety embracing shawls, waistcoating etc. of the most elegant patterns and finest fabrics.

The painting (previous page, below) is of the Cloth Hall in 1815.

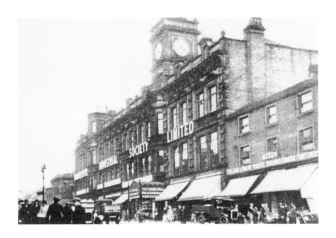

Huddersfield Co-op

The Co-op comprises two very distinct buildings. The first, built in 1906 is notable for its distinctive clock tower. The extension, by contrast, is an ill-fitting modernist edifice notable only for its long continuous ribbon horizontal windows. However, it does have its fans:

> the former Huddersfield Co-op is the first and best example of a truly modern building in Huddersfield. It has a handsome composition and is a very good 1930s commercial building. It must have been revolutionary in its design in Huddersfield on its opening on 29 May 1937... Its elements and massing provoke an emotional response that is unique in Huddersfield. Its delicious simplicity, elegance and asymmetry is not seen elsewhere in the town.

> Christopher Marsden, *The Significance of the Huddersfield Cooperative Extension*

> ...it gives the town of Huddersfield a store that is entirely modern in design and equipped on the most up-to-date lines-a store of which the townspeople generally, and co-operators in particular, can be proud...

> *Huddersfield Daily Examiner*, 29 May 1937

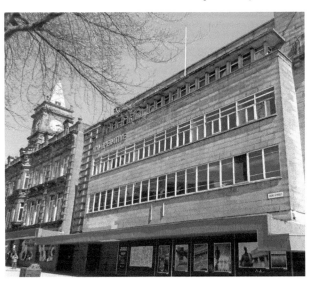

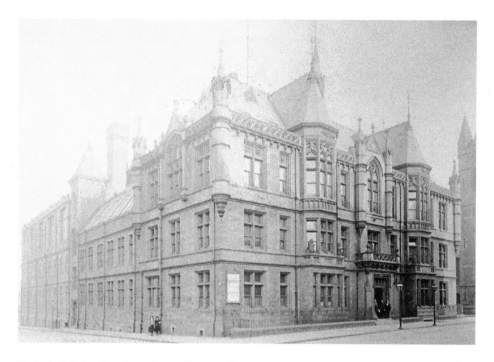

Technical School and Mechanics' Institution, 1884

Huddersfield Technical School and Mechanics' Institute was formed from a merger between the Huddersfield Mechanics' Institution and the Huddersfield Female Educational Institute in 1884. It became the Huddersfield Technical College in 1896 and the College of Technology in 1958. In 1970 the College and the Oastler College amalgamated to form Huddersfield Polytechnic which became the University of Huddersfield in 1992. Oastler College of Education was a day teacher training institution. Modern architecture for a modern university in the lower picture.

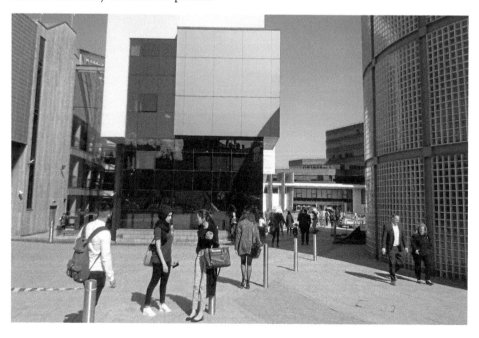

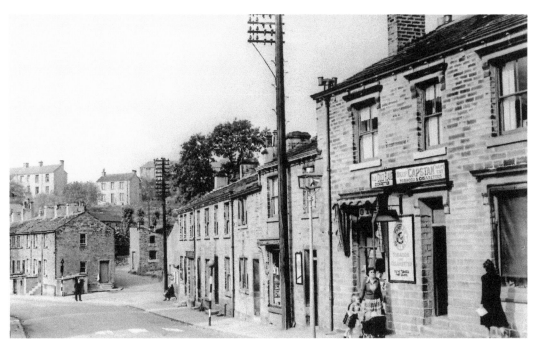

North Road, Kirkburton
August 1952

Woollen cloth manufacturing was well established here by the time of Queen Elizabeth I. By 1880 there were eight mills operating. Other industries included leather tanning and coal mining; by 1850 there were twenty small pits here. During the Civil War the villagers supported the Parliamentary cause. The priest, Gamaliel Whitaker, however, was a Royalist; when government forces went to arrest him in 1644 the soldiers shot his wife, Hester, in the ensuing confusion. Kirkburton boasts a rapier dance team, who perform traditional longsword dances on New Year's Day at local pubs. Rapier dancing was a tradition in the village up to the beginning of the twentieth century, and was revived in 1974. The tradition of sporting blackened faces is still maintained. The George Inn in George Street is in the lower picture.

93

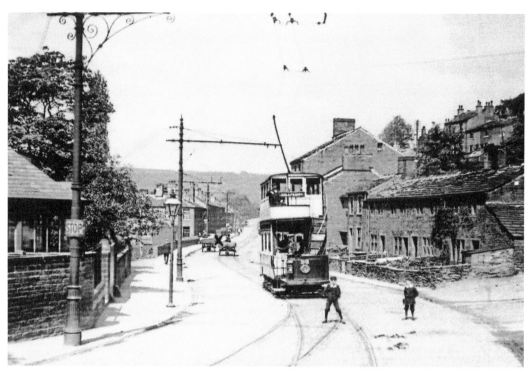

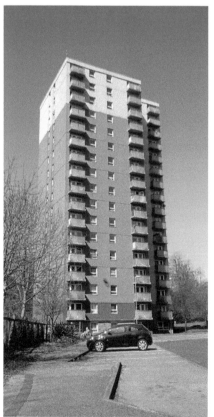

Berry Brow – before it was 'a village of the future'.
A 1965 National Film Archive documentary which

addresses the changes taking place in the small
village of Berry Brow...The village is amidst a
huge change where the traditional terraced
houses are being knocked down to make way for
the tower blocks of the future, creating the "new"
Berry Brow...The film continues onto the station's
waiting room revealing the dull, derelict nature
of the place. Evocative sounds of a ghost train
accompany these images... ...The documentary
continues onto show Salem Terrace and the large
Methodist Church that has been left in ruin.
Broken windows and the crumbling brickwork
can be seen... the cottages are being demolished.
The demolition is shown through close-ups during
which a huge metal wrecking ball hits the small
buildings. This is followed by scenes of the derelict
land. The commentary explains that Berry Brow
is to be a village of the future. New tower blocks
are being built on the hillsides as well as uniform
bungalows, built in neat rows, which await new
tenants. The film finishes with scenes of Berry
Brow accompanied by William Blake's "Jerusalem"
looking onto a brave, modern new world.

Yorkshire Film Archive, film No. 2490

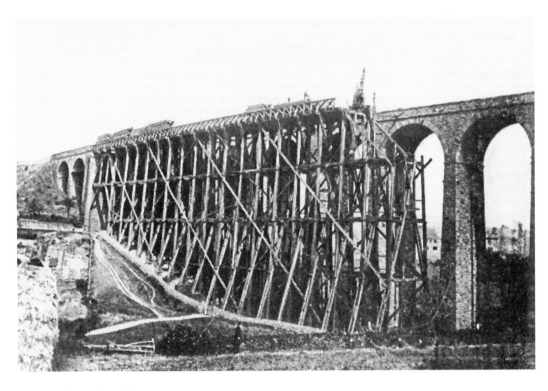

Denby Dale Viaduct
The old 1850 wooden viaduct being dismantled to reveal the stone viaduct in 1880.

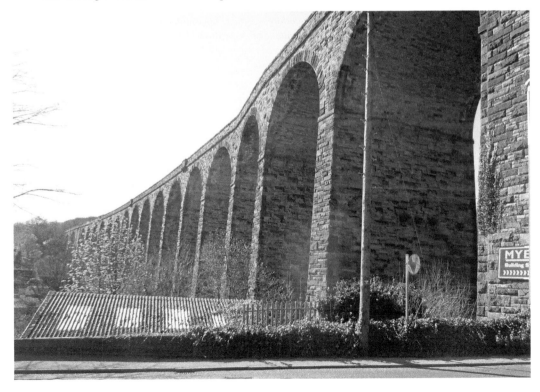

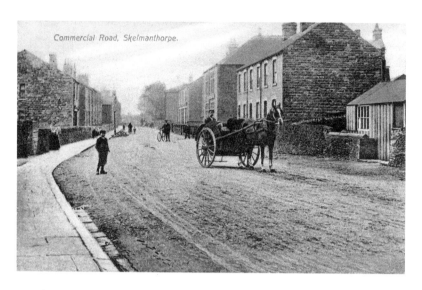

Commercial Road, Skelmanthorpe

Locals call the village 'Shat': an abbreviation of 'Shatterers' – local labour which was hired during construction of the railway to break or 'shatter' rocks. The village has a decidedly colourful history: in the 1770s, Skelmanthorpe Feast was a riotous affair with bull and bear-baiting and dog fights on the village green. John Taylor records in 1882 that

> Public houses were crowded with drunken revellers, who caroused all day and made night hideous with quarrels and disturbances ... Among these scenes of revelry were mountebanks, showmen, fortune telling Gypsies, vagabonds and thieves from every quarter.

Reminiscences of Isaac Marsden

Skelmanthorpe Feast now takes place annually on the field next to The Chartist and across the road from what was the Three Horse Shoes.

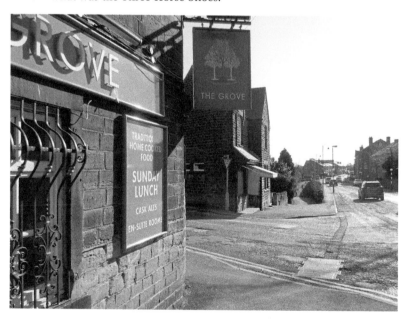